The Royal Horticultural Society

TREASURY
of TREES

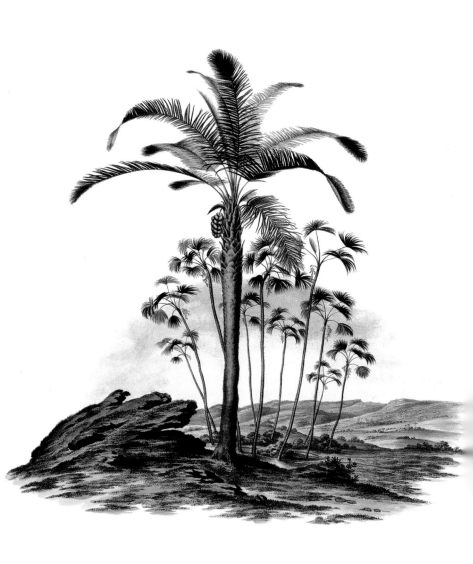

The Royal Horticultural Society

TREASURY
of TREES

Writers and Artists in the Garden

Selected by Charles Elliott

With illustrations from the
Royal Horticultural Society's Lindley Library

FRANCES LINCOLN LIMITED
PUBLISHERS

Frances Lincoln Limited
4 Torriano Mews
Torriano Avenue
London NW5 2RZ
www.franceslincoln.com

The Royal Horticultural Society Treasury of Trees
Copyright © Frances Lincoln Limited 2007

Text selected by Charles Elliott

Illustrations copyright © the Royal Horticultural Society 2006
and printed under licence granted by the Royal Horticultural
Society, Registered Charity number 222879.
Profits from the sale of this book are an important contribution
to the funds raised by the Royal Horticultural Society.

British Library cataloguing-in-publication data
A catalogue record for this book is available from
the British Library

ISBN 13: 978-0-7112-2736-1

Printed in Hong Kong

1 3 5 7 9 8 6 4 2

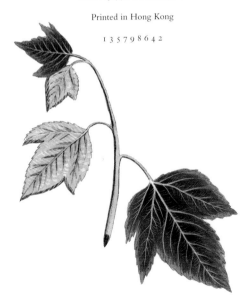

CONTENTS

INTRODUCTION

People care about trees. More than most plants, they have the power to touch our emotions, cheering us, calming us, sometimes even frightening us, especially when they crowd together in forests. Life would be very strange and barren indeed without them. Most of us recognize this, but it is still surprising to discover the intensity of feeling that trees can arouse in poets and other writers. This anthology is proof of that.

What's most remarkable is the close focus. While there are of course writers here who simply use trees as scene-setting, or to pin down a moral, far more of them are clearly fascinated, occasionally to the point of obsession, by a tree itself, or its fruit, or its place in the landscape. A tree may be a token of memory, as in James McBride Dabbs's little quatrain, in which a Lombardy poplar recalls the horror of a war-blasted road in France. Or it may be the source of a peculiarly vivid metaphor, as when Hugh MacDiarmid finds in a hawthorn a startling analogy with his own poetry. Or it may serve as a way to convey the agony of a crime, as in Paul Laurence Dunbar's moving ballad of a lynching told in the person of the old oak on whose branch the noose was hung. In each case, the writer's close attention to the trees involved make the passages even more powerful than they would be otherwise.

Similarly, even the more descriptive extracts betray a kind of awe, as if these giant living objects are in some way more deeply connected to our lives than their smaller relatives in the herbaceous border or the wildflower meadow. The Chinese poet Po Chü-i,

writing 1,300 years ago, contemplates the pine trees growing in his courtyard and concludes that he does not deserve to be their master; Francis Kilvert visits Moccas Park in Herefordshire in 1876 and is thoroughly intimidated by the ancient oaks, which 'look as if they had been at the beginning and the making of the world', and would 'probably see its end'; tough-minded John Muir, describing the trees of Yosemite a century ago, is brought to a halt by the 'singular majesty' of the Wellingtonia, looking 'as strange in aspect and behavior among its neighbour trees as would the mastodon among the homely bears and deer.'

Beyond awe, however, certain trees apparently have the capacity to inspire simple joy, or even something approaching ecstasy. What could be more cheerful than Shakespeare's holly song, or more redolent of sheer delight than the medieval Welsh poet Dafydd ap Gwilym's paean of praise to the birch wood – especially its erotic potential? Personally, I prize (and find unforgettable) the couplet in which George Peele, the Elizabethan poet (and Shakespeare collaborator) manages to combine God, a 'whizzing' wind and mulberry trees to create a small epiphany. It proves to me – if proof were needed – that there is something slightly unearthly, or at least inexplicable, about what happens when writers and trees get together. Browse this collection of extracts and you'll see what I mean.

Charles Elliott

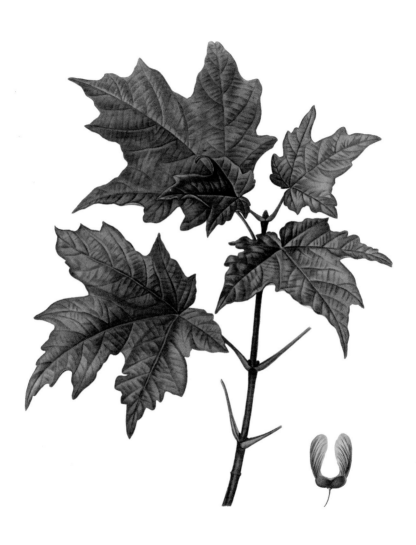

Sugar Maple

It is only for a brief period that the blossoms of our sugar maple are sweet-scented; the perfume seems to become stale after a few days; but pass under this tree just at the right moment, say at nightfall on the first or second day of its perfect inflorescence, and the air is laden with its sweetness; its perfumed breath falls upon you as its cool shadow does a few weeks later.

John Burroughs, Wake-Robin *(1871)*

YEW

Nay, Traveller! rest. This lonely yew tree stands
Far from all human dwelling: what if here
No sparkling rivulet spread the verdant herb?
What if the bee love not these barren boughs?
Yet, if the wind breathe soft, the curling waves,
That break upon the shore, shall lull thy mind
By one soft impulse saved from vacancy.

William Wordsworth,
'Lines left upon a Seat in a Yew-tree',
Lyrical Ballads *(1798)*

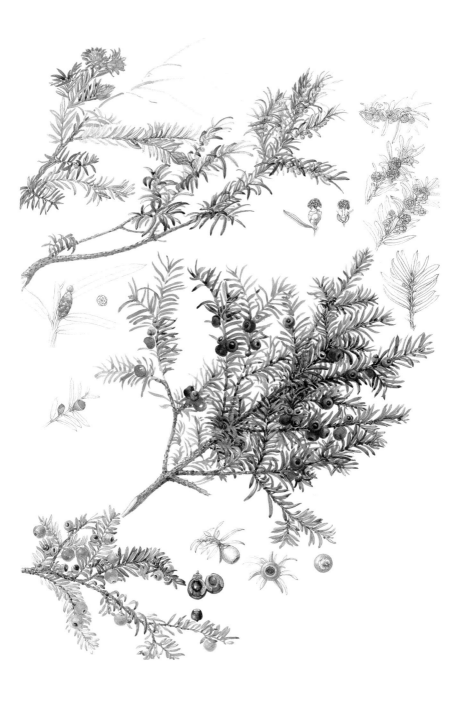

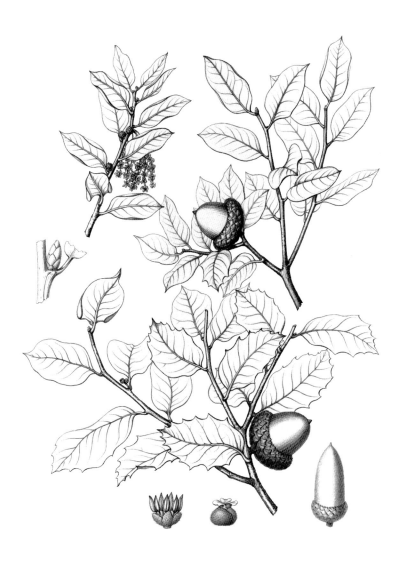

GOLDCUP OAK

The mountain live-oak, or goldcup oak (*Quercus chrysolepis*) [is] a sturdy mountaineer of a tree, growing mostly on the earthquake taluses and bench of the sunny north wall of the Valley. In tough, unwedgeable, knotty strength, it is the oak of oaks, a magnificent tree.

The largest and most picturesque specimen in the Valley is near the foot of Tenaya Fall, a romantic spot seldom seen on account of the rough trouble of getting to it. It is planted on three huge boulders and yet manages to draw sufficient moisture and food from this craggy soil to maintain itself in good health. It is twenty feet in circumference, measured above a large branch between three and four feet in diameter that has been broken off. The main knotty trunk seems to be made up of craggy granite boulders like those on which it stands, being about the same color as the mossy, lichened boulders and about as rough. Two moss-lined caves near the ground open back into the trunk, one on the north side, the other on the west, forming picturesque, romantic seats. The largest of the main branches is eighteen feet and nine inches in circumference, and some of then long pendulous branchlets droop over the stream at the foot of the fall where it is gray with spray. The leaves are glossy yellow-green, ever in motion from the wind from the fall. It is a fine place to dream in, with falls, cascades, cool rocks lined with hypnum three inches thick; shaded with maple, dogwood, alder, willow; grand clumps of lady-ferns where no hand may touch them; light filtering through translucent leaves; oaks fifty feet high, lilies eight feet high in a filled lake basin near by, and the finest libocedrus groves and tallest ferns and goldenrods.

John Muir, The Yosemite *(1912)*

PLANE

For an enormous plane tree, with a whitish, blotchy trunk thicker than that of any other tree in the garden, and, I think, the whole province, her admiration overflowed into reverence. Of course, it wasn't 'Grandmother Josette' who planted it, but Ercole I d'Este himself, or Lucretia Borgia.

'Do you realize? It's nearly 500 years old!' she murmured, her eyes widening. 'Just imagine all the things it must have seen, since it came into the world!'

And it seemed as if it had eyes like ours, the great ugly beast, that gigantic old plane tree: eyes to see us well as ears to hear us.

Giorgio Bassani, The Garden of the Finzi-Continis *(1962)*

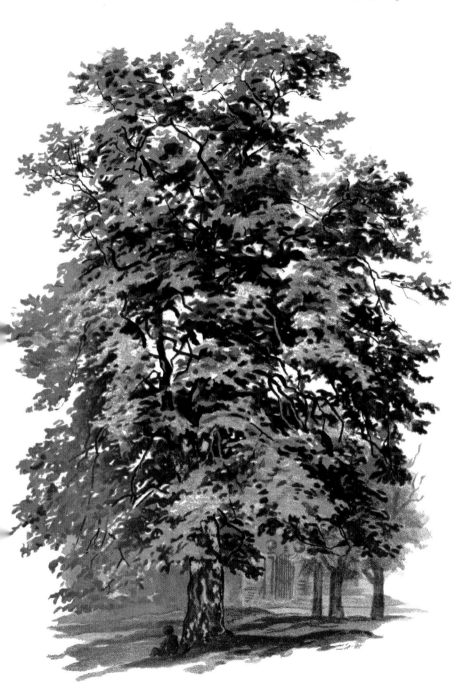

TULIP TREE

I stand alone
in my great height.
I cherish nothing

More than my own roots.
the decay of the world
is my nourishment.

What happens below me
passes like the floss
from autumn milkweed;

And the stars
are no more than the hum of gnats
tossing in the vault

of my summer shade.
Not death not grief
not the thunder of human history

sways the vast and wrinkled
stone of my trunk.
My joy is in the sun

and the rain and the passionate
art of the wind
stirring like a lover

the enormous green play
of my branches.
What dies beneath me

finds no pity,
but in time is taken up
and sent out briefly to dance:

a nameless leaf in the wide
blue music of the weather.
And you, far below,

Tulip tree (cont.)

with your small face
looking up, I have no need
for homage.

Your human heart
is no more to me than a sparrow's
egg blown from its nest.

But if sometimes
out of loneliness or a desperate
urge to praise

you would seek me out,
then press your faint hand
reverently against

the ancient hide of my bark.
In a hundred years
your touch will travel through

each ring of my immense
armoured heart, to tell me
you were here.
till in the air
there comes the smell
of calamus
from wet, gummy stalks.

Joe Salerno,
'The Song of the Tulip Tree' (1999)

ELDER

And the ghostly, creamy coloured little tree of leaves
white, ivory white among the rambling greens
how evanescent, variegated elder, she hesitates on the green grass
as if, in another moment, she would disappear
with all her grace of foam!

D. H. Lawrence, from 'Trees in the Garden', Last Poems (1932)

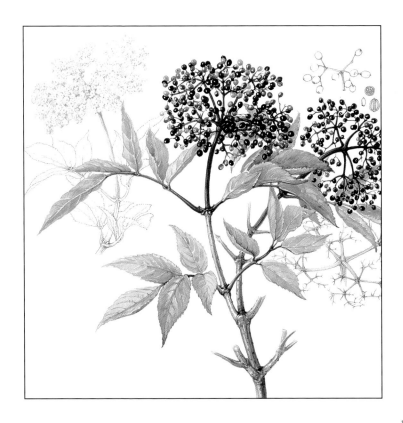

HOLLY

Blow, blow thou winter wind –
Thou art not so unkind
As man's ingratitude!
Thy tooth is not so keen,
Because thou art not seen,
Although thy breath be rude.
Heigh ho! sing heigh ho! unto the green holly:
Most friendship is feigning, most loving mere folly.
Then heigh ho! the holly!
This life is most jolly!

Freeze, freeze, thou bitter sky –
Thou dost not bite so nigh
As benefits forgot!
Though thy waters warp,
Thy sting is not so sharp
As friend remembered not.
Heigh ho! sing heigh ho! unto the green holly,
Most friendship is feigning, most loving mere folly.
Then heigh ho, the holly!
This life is most jolly!

William Shakespeare, As You Like It *(1600)*

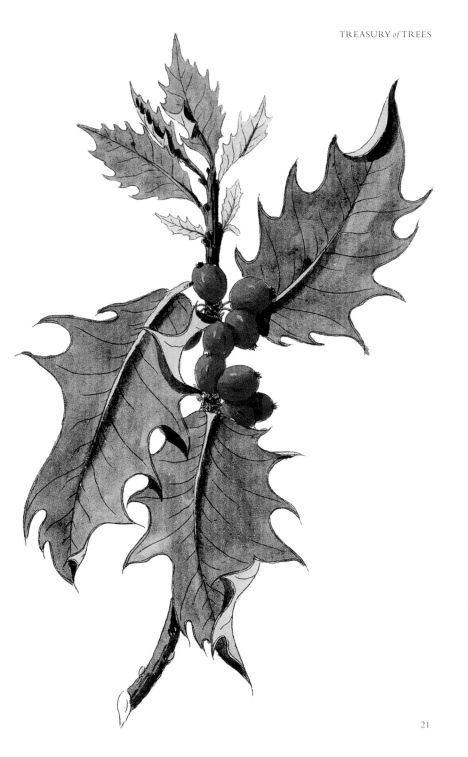

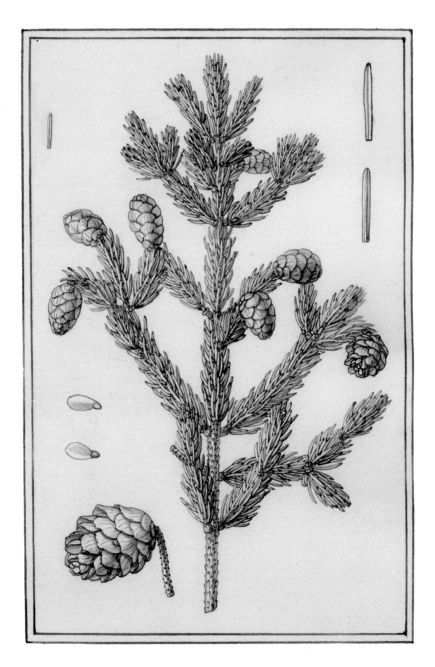

HEMLOCK

The ancient hemlocks, whither I propose to take the reader, are rich in many things besides birds. Indeed, their wealth in this respect is owing mainly, no doubt, to their rank vegetable growth, their fruitful swamps, and their dark, sheltered retreats.

Their history is of an heroic cast. Ravished and torn by the tanner and his thirst for bark, preyed upon by the lumberman, assaulted and beaten back by the settler, still their spirit has never been broken, their energies never paralyzed. Not many years ago a public highway passed through them, but it was at no time a tolerable road; trees fell across it, mud and limbs choked it up, till finally travelers took the hint and went around; and now, walking along its deserted course, I see the footprints only of coons, foxes, and squirrels.

Nature loves such woods, and places her own seal upon them. Here she shows me what can be done with ferns and mosses and lichens. Standing in these fragrant aisles, I feel the strength of the vegetable kingdom, and am awed by the deep and inscrutable processes of life going on so silently about me.

John Burroughs, Wake-Robin *(1871)*

LIME

I have seen a tall or great-bodied Lime tree, bare without boughes for eight foote high, and then the branches were spread round about so orderly, as if it were done by art, and brought to compasse that middle Arbour; And from those boughes the body was bare againe for eight or nine foote (wherein might be placed halfe a hundred men at the least), and then another row of branches to encompasse a third Arbour, with stayres, made for the purpose, to this and that underneath it: upon the boughes were laid boards to tread upon, which was the goodliest spectacle mine eyes ever beheld for one tree to carry.

John Parkinson, Paradisi in Sole Paradisus Terrestris *(1629)*

The linden broke her ranks and rent
 The woodbine wreaths that bind her,
And down the middle, buzz! She went
 With all her bees behind her.

Alfred Lord Tennyson, 'Amphion', Poems *(1842)*

BREADFRUIT

The bread-fruit tree, in its glorious prime, is a grand and towering object, forming the same feature in a Marquesan landscape that the patriarchal elm does in New England scenery. The latter tree it not a little resembles in height, in the wide spread of its stalwart branches, and in its venerable and imposing aspect.

The leaves of the bread-fruit are of great size, and their edges are cut and scolloped as fantastically as those of a lady's lace collar. As they annually tend toward decay, they almost rival, in the brilliant variety of their gradually changing hues, the fleeting shades of the expiring dolphin. The autumnal tints of our American forests, glorious as they are, sink into nothing in comparison with this tree.

The leaf, in one particular stage, when nearly all the prismatic colours are blended on its surface, is often converted by the natives into a superb and striking head-dress. The principal fibre traversing its length being split open a convenient distance, and the elastic sides of the aperture pressed apart, the head is inserted between them, the leaf drooping on one side, with its forward half turned jauntily up on the brows, and the remaining part spreading laterally behind the ears.

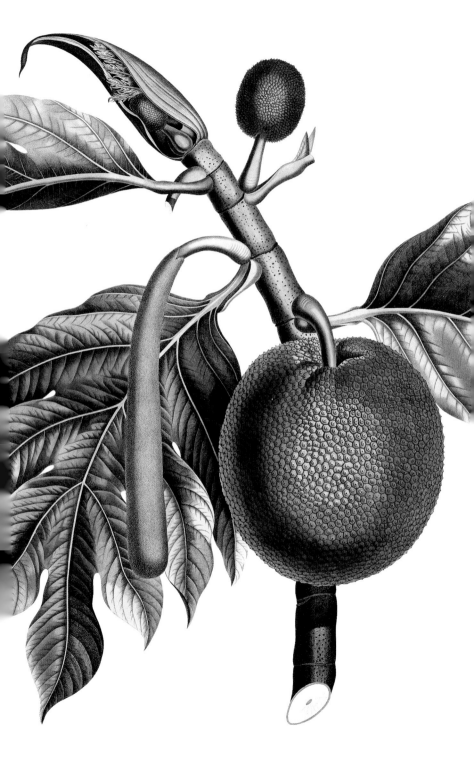

Breadfruit (cont.)

The fruit somewhat resembles in magnitude and general appearance one of our citron melons of ordinary size; but, unlike the citron, it has no sectional lines drawn along the outside. Its surface is dotted all over with little conical protuberances, looking not unlike the knobs on an antiquated church door. This rind is perhaps an eighth of an inch in thickness; and denuded of this, at the time when it is inn greatest perfection, the fruit presents a beautiful globe of white pulp, the whole of which may be eaten, with the exception of a slender core, which is easily removed.

The bread-fruit, however, is never used, and is indeed altogether unfit to be eaten, until submitted in one form or another to the action of fire.

Herman Melville, Typee *(1846)*

DOUGLAS FIR

At midday I reached my long-wished Pinus (called by the Umpqua tribe Natele), and lost no time in examining and endeavouring to collect specimens and seeds. New or strange things seldom fail to make great impressions, and often at first we are liable to over-rate them; and lest I should never see my friends to tell them verbally of this most beautiful and immensely large tree, I now state the dimensions of the largest one I could find that was blown down by the wind: Three feet from the ground, 57 feet nine inches in circumference; 134 feet from the ground, 17 feet 5 inches; extreme length 215 feet. The trees are remarkably straight; bark uncommonly smooth for such large timber, of a whitish or light brown colour, and yield a great quantity of gum of a bright amber colour. The large trees are destitute of branches, generally two-thirds the length of the tree; branches pendulous, and the cones hanging from their points like small sugar-loaves in a grocer's shop. . . . Being unable to climb or hew down any, I took my gun and was busy clipping them from the branches with ball when eight Indians came at the report of my gun. They were all painted with red earth, armed with bows, arrows, spears of bone, and flint knives, and seemed anything but friendly. I endeavoured to explain to them what I wanted and they seemed satisfied and sat down to smoke, but no sooner had done so than I perceived one string his bow and another sharpen his flint knife with a pair of wooden pincers and hang it on

Douglas fir (cont.)

the wrist of the right hand, which gave me ample testimony of their inclination. To save myself I could not do so by flight, and without any hesitation I went backward six paces and cocked my gun, and then pulled from my belt one of my pistols, which I held in my left hand. I was determined to fight for life. As I as much as possible endeavoured to preserve my coolness and perhaps did so, I stood eight or ten minutes looking at them and they at me without a word passing, till one at last, who seemed to be the leader, made a sign for tobacco, which I said they should get on condition of going to fetch me some cones. They went, and as soon as out of sight I picked up my three cones and a few twigs and made a quick retreat to my camp, which I gained at dusk.

David Douglas, Diary *(1826)*

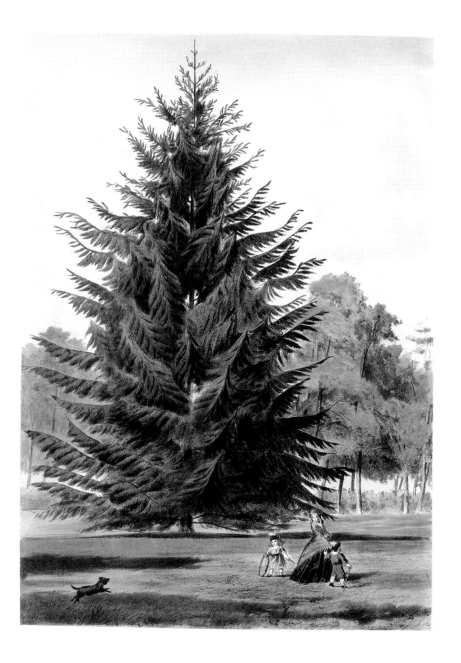

REDWOOD

Only stand high a long enough time your lightning
 will come; that is what blunts the peaks of
 redwoods;
But this old tower of life on the hilltop has taken
 it more than twice a century, this knows in
 every
Cell the salty and burning taste, the shudder
 and the voice.

 The fire from heaven; it has
 felt the earth's too
Roaring uphill in autumn, thorned oak-leaves tossing
 their bright ruin to the bitter laurel-leaves,
 and all
Its under-forest has died and died, and lives to be
 burnt; the redwood has lived. Though the fire
 entered,
It cored the trunk while the sapwood increased. The
 trunk is a tower, the bole of the trunk is a
 black cavern,
The mast of the trunk with its green boughs the
 mountain stars are strained through
Is like the helmet spike on the highest head of an
 army; black on lit blue or hidden in cloud
It is like the hill's finger in heaven. And when the
 cloud hides it, though in barren summer, the
 boughs make their own rain.

Old Escobar had a cunning trick
 when he stole beef. He and his grandsons
Would drive the cow up here to a starlight death and
 hoist the carcass into the tree's hollow,
Then let them search his cabin he could smile for
 pleasure, to think of his meat hanging secure
Exalted over the earth and the ocean, a theft like a
 star, secret against the supreme sky.

Robinson Jeffers, 'The Summit Redwood', Cawdor and Other Poems *(1928)*

ARBORVITAE

With honeysuckle, over-sweet, festoon'd;
With bitter ivy bound;
Terraced with funguses unsound;
Deform'd with many a boss
And closed scar, o'ercushion'd deep with moss;
Bunch'd all about with pagan mistletoe;
And thick with nests of the hoarse bird
That talks, but understands not his own word;
Stands, and so stood a thousand years ago,
A single tree.
Thunder has done its worst among its twigs,
Where the great crest yet blackens, never pruned,
But in its heart, alway
Ready to push new verdurous boughs, whene'er
The rotting saplings near it fall and leave it air,
Is all antiquity and no decay.
Rich, though rejected by the forest-pigs,
Its fruit, beneath whose rough, concealing rind
They that will break it find
Heart-succouring savour of each several meat,
And kernell'd drink of brain-renewing power,
With bitter condiment of sweet and sour,
And sweet economy of sweet,
And odours that remind
Of haunts of childhood and a different day
Beside this tree,
Praising no Gods nor blaming, sans a wish,
Sits, Tartar-like, the Time's civility,
And eats its dead-dog off a golden dish.

Coventry Patmore, 'Arbor Vitae', The Unknown Eros *(1877)*

WESTERN JUNIPER

The juniper or Red Cedar (*Juniperus occidentalis*) is preëminently a rock tree, occupying the baldest domes and pavements in the upper silver fir and alpine zones, at a height of 7000 to 9500 feet. In such situations, rooted in narrow cracks or fissures, where there is scarcely a handful of soil, it is frequently over eight feet in diameter and not much more in height. The tops of old trees are almost always dead, and large stubborn-looking limbs push out horizontally, most of them broken and dead at the end, but densely covered, and imbedded here and there with tufts or mounds of gray-green scalelike foliage. Some trees are mere storm-beaten stumps about as broad as long, decorated with a few leafy sprays, reminding one of the crumbling towers of old castles scantily draped with ivy. Its homes on bare, barren dome and ridge-top seem to have been chosen for safety against fire, for, on isolated mounds of sand and gravel free from grass and bushes upon which fire could feed, it is often found growing tall and unscathed to a height of forty to sixty feet, with scarce a trace of the rocky angularity and broken limbs so characteristic a feature throughout the greater part of its range. It never makes anything like a forest; seldom even a grove. Usually it stands out separate and independent, clinging by slight joints to the rocks, living chiefly on snow and thin air and maintaining sound health on this diet for 2000 years or more. Every feature or every gesture it makes expresses steadfast, dogged endurance. The bark is a bright cinnamon color and is handsomely braided and reticulated on thrifty trees, flaking off in thin, shining ribbons that are sometimes used by the Indians for tent matting. Its fine color and picturesqueness are appreciated by artists, but to me the juniper seems a singularly strange and taciturn tree. I have

spent many a day and night in its company and have always found it silent and rigid. It seems to be a survivor of some ancient race, wholly unacquainted with its neighbors. Its broad stumpiness, of course, makes wind-waving or even shaking out of the question, but it is not this rocky rigidity that constitutes its silence. On calm, sun-days the sugar pine preaches like an enthusiastic apostle without moving a leaf. On level rocks the juniper dies standing and wastes insensibly out of existence like granite, the wind exerting about as little control over it, alive or dead, as it does over a glacier boulder.

John Muir, The Yosemite *(1912)*

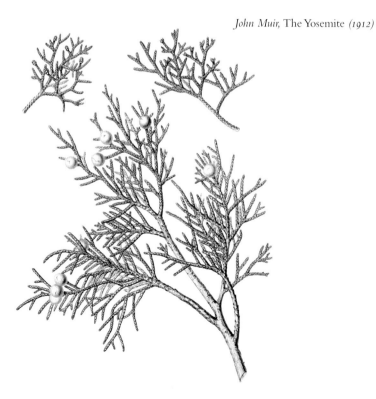

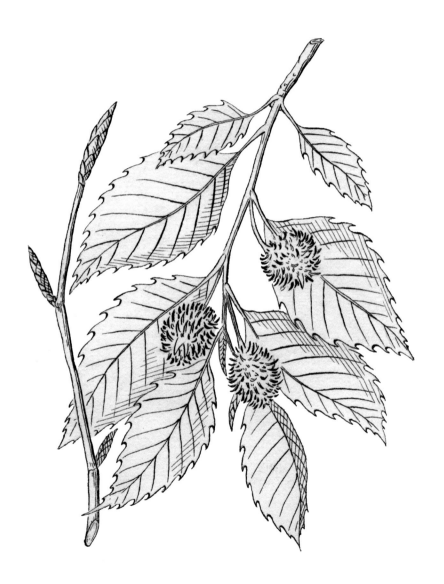

AMERICAN BEECH

Where the climb and the gale stifle the debate
where the beeches face the sea defenceless
all's reduced to the splendour of great height
the last quivering leaves, like us, breathless
from the big argument. Only iron
branches elbow out on this side, the sea side,
the gale side, trunks blasted to a sheen
gun-grey, so absolute we disregard

the lapse and flux of colours too fleeting
to fix with names – green swilling over amber –
and the fields below unstable. The beeches
could recall copperiness or rustling
sweet attics diverting us all the summer
and somehow confusing clear-cut issues.

Judy Gahagan, 'Where the Beeches', Night Calling *(2003)*

PINE

Below the Hall what meets my eyes?
Ten pine trees growing near to the steps.
Irregularly scattered, not in an ordered line;
In height also strangely unassorted.
The highest of them is thirty feet tall;
The lowest scarcely measures ten feet.
They have the air of things growing wild;
Who first planted them, no one now knows.
They touch the walls of my blue-tiled house;
Their roots are sunk in the terrace of white sand.
Morning and evening they are visited by the wind and moon;
Rain or fine – they are free from dust and mud.
In the gales of autumn they whisper a vague tune;
From the suns of summer they yield a cool shade.
At the height of spring the fine evening rain
Fills their leaves with a load of hanging pearls.
At the year's end the time of great snow
Stamps their branches with a fret of glittering jade.
At each season they have their varying mood;
Vying in this with any tree that grows.
Last year, when they heard I had bought this house,
Neighbours mocked and the World called me mad –
That a whole family of twice ten souls
Should move house for the sake of a few pines!
Now that I have come to them, what have they given me?
They have only loosened the shackles that bind my heart.
But even so, they are 'profitable friends',

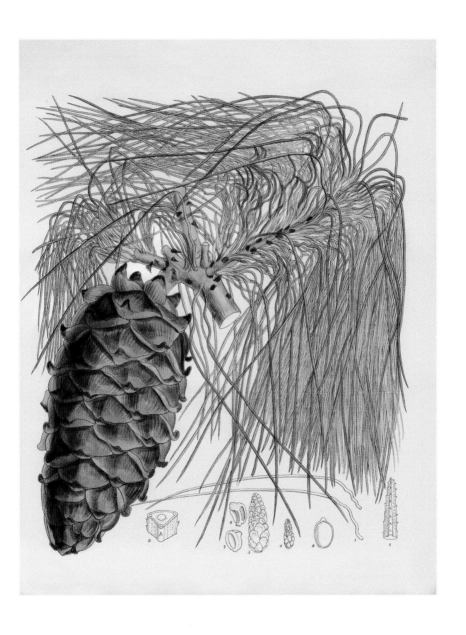

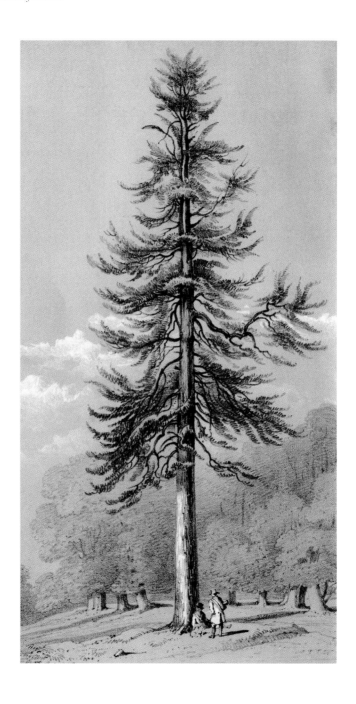

Pine (cont.)

And fill my need of 'converse with wise men'.
Yet when I consider how, still a man of the world,
In belt and cap I scurry through dirt and dust,
From time to time my heart twinges with shame
That I am not fit to be the master of my pines!

Po Chü-i (821), translated by Arthur Waley

In the dark pine-wood
 I would we lay,
In deep cool shadow
 At noon of day.

How sweet to lie there,
 Sweet to kiss,
Where the great pine-forest
 Enaisled is!

Thy kiss descending
 Sweeter were
With a soft tumult
 Of thy hair.

O unto the pine-wood
 At noon of day
Come with me now
 Sweet love, away.

James Joyce 'In the dark pine-wood',
Chamber Music *(1907)*

ELM

My two favourite elm trees at the back of the hut
are condemned to dye – it shocks me to relate it
but tis true – the savage who owns them thinks
they have done their best & now he wants to
make use of the benefits he can get from selling
them – O was this country Egypt and I was but a
caliph the owner should loose his ears for his
arrogant presumption & the first wretch that
buried his axe in their roots should hang on their
branches as a terror to the rest – I have been
several mornings to bid them farewell – had I but
£100 to spare I would buy their reprieves – but
they must dye . . . was People all to feel & think as
I do the world coud not be carried on – a green
woud not be ploughd a tree or bush would not be
cut for firing or furniture & every thing they
found when boys would remain in that state till
they dyd – this is my indisposition & you will
laugh at it.

John Clare, letter dated 7 March 1821

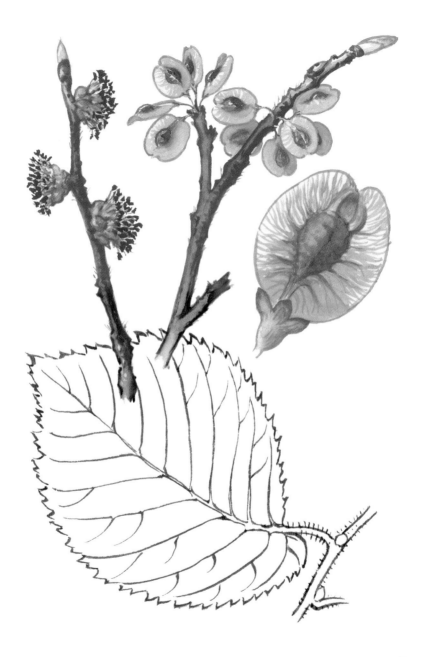

Elm (cont.)

But what shall I then say of our late prodigious Spoilers, whose furious devastation of so many goodly Woods and Forests have left an infamy on their Names and Memories not quickly to be forgotten! I mean our unhappy Usurpers, and injurious Sequestrators; Not here to mention the deplorable necessities of a Gallant and Loyal Gentry, who for their Compositions were (many of them) compell'd to add yet to this Waste, by an inhumane and unparallel'd Tyranny over them, to preserve the poor remainder of their Fortunes, and to find them Bread.

Nor was it here they desisted, when, after the fate of that beautiful Grove under Greenwich Castle, the Royal Walk of Elms in St. James's Park,

That living Gallery of aged Trees

(as our excellent Poet calls it) was once proposing to the late Council of State to be cut down and sold, that with the rest of His Majesties Houses already demolish'd, and mark'd out for destruction, His Trees might likewise undergo the same destine, and no footsteps of Monarchy remain unviolated. This a Truth; which coming by chance to hear of, I so conjur'd a powerful Member of it (and one who was to strike a principal stroake in this barbarous Execution) that if my Authority did not rescue those Trees from the Ax, sure I am, my Arguments did abate the edge of it; nor do I ever pass under that Majestical shade but methinks I hear it salute me as once the Hamadryad did the good Rinaldo,

Ben caro giungi in queste chiostre amene.

John Evelyn, Sylva *(1664)*

BLACK POPLAR

By the spring of 1976 I had become accustomed to the [black poplar's] unique profile myself, and that April I recognized – noticed, to tell the truth – my valley poplar for the first time. It was visible half a mile away, tilted over towards the south, its switches of twigs ablaze with crimson catkins. Closer to I could make out all the typical features of *P. nigra*: the gnarled and furrowed bark, covered with huge round burrs; the sweep of the main branches downwards, close to the ground; and the upwards sweep of the bunches of shoots. Even the lean was in character, and has been getting black poplars a bad name as far back as the middle ages. In an Essex court roll for 1422 there is a reference to 'one ancient and decayed [black] poplar growing out too far over the king's highway'. But the farmer on whose land my tree was growing gave a new slant on this particular specimen's spectacular tilt. Apparently there had been two poplars at one time, very close to one another, and they had grown apart into a V, each searching for light and space. The elder of the two trees had been felled only a few years ago, as it was nearing the end of its life.

It was remarkable that two black poplars should have survived so long in what is predominantly arable countryside. They are trees of open, damp meadowland, and are very vulnerable to ploughing and drainage. Since they rarely produce suckers, the felling of a mature tree usually means its extinction on that spot. And since the timber is now regarded as worthless (though it was used for crucks in medieval buildings) black poplars are rarely replanted. Yet here on this ancient boundary line,

Black poplar (cont.)

between two farms, two parishes, two counties, the surviving tree has escaped even being cut back. Just what its future prospects are, I would not like to say. When I measured its girth, it was nearly 15 feet, making the tree somewhere between 150 and 200 years old. This is a good span for a poplar, and already the first signs of old age – the shedding of the arched lower branches – has begun. Yet when it does die, it may not mean the end of black poplars in this valley. Whilst I was searching through the hedge on the far side of the trunk I found what I thought was a drooping branch from the main tree. But it turned out to be a quite separate shoot, sprung, as far I could tell, from the now invisible stump of the felled tree, like a shoot from a coppice stool. It was already 4 feet high and in the shelter of the edge stood a good chance of surviving.

Richard Mabey, The Flowering of Britain *(1980)*

FASTIGIATE CHERRY

I would like to complain of the fastigiate cherry called 'Amanogawa.' It is upright, all right, to the point of absurdity, in its youth. It can be ten feet high and a foot wide, and it is as charming as it is ridiculous when strung with its puffy little flowers. As it ages, however, it thickens out in a fairly alarming way, if one has counted on a shape like an exclamation point. Certain dogs and, I suppose, certain humans, are also a bit disappointing as they mature, so I do not condemn the cherry tree; I merely point out that its slender form is not as permanent as one hopes. Another thing about flowering cherries: nobody seems to dwell on their awful roots. So often have I reflected it would be better if some of those rhapsodists of the cherry tree grew a few of them, for there is nothing like familiarity to dampen one's initial ardour. Cherries have roots as invasive as maples, and it is quite easy to see, beneath old cherry trees, the starved and barren nature of the ground. And yet they are almost supremely beautiful.

Henry Mitchell, The Essential Earthman *(1981)*

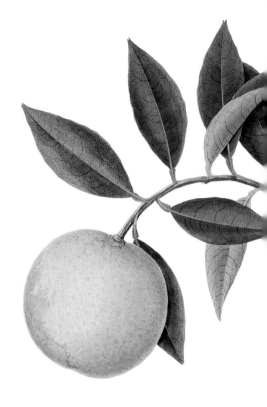

ORANGE

Oh that I were an Orenge Tree,
 That busie plant!
Then should I ever laden be,
 And never want
Some fruit for Him that dressed me.

George Herbert, 'Employment', The Temple *(1633)*

WILLOW

Down by the salley gardens my love and I did meet;
She passed the salley gardens with little snow-white feet.
She bid me take love easy, as the leaves grow on the tree;
But I, being young and foolish, with her would not agree.

In a field by the river my love and I did stand,
And on my leaning shoulder she laid her snow-white hand.
She bid me take life easy, as the gross grows on the weirs;
But I was young and foolish, and now am full of tears.

William Butler Yeats, 'Down by the Salley Gardens' (1889)

Boundless the leaves roused by spring,
Countless the twigs which tremble in the dawn.
Whether the willow can love or not,
Never a time when it does not dance.
Brown fluff hides white butterflies
Drooping bands disclose the yellow oriole.
The beauty which shakes a kingdom must reach through all the body:
Who comes only to view the willow's eyebrows?★

Li Shang-yin (ninth century), translated by A. C. Graham

★ The phrase 'willow's eyebrows' refers both to the willow leaf and the eyebrows of a
beautiful woman.

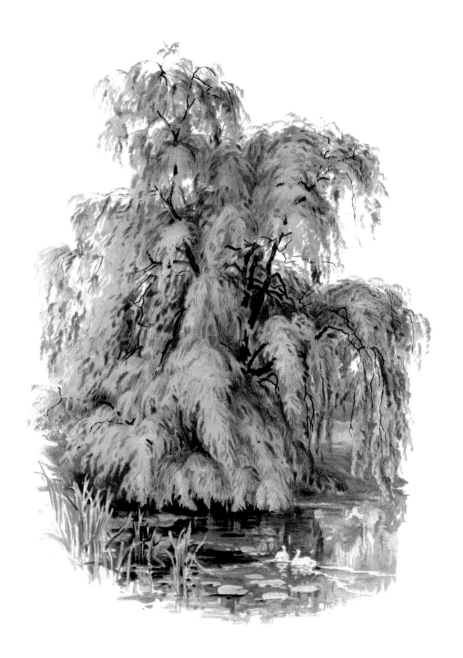

Black Walnut

My mother and I debate:
we could sell
the black walnut tree
to the lumberman,
and pay off the mortgage.
Likely some storm anyway
will churn down its dark boughs, smashing the house. We talk
slowly, two women trying
in a difficult time to be wise.
Roots in the cellar drains,
I say, and she replies
that the leaves are getting heavier
harder to gather away.
But something brighter than money
moves in our blood – an edge
sharp and quick as a trowel
that wants us to dig and sow.
So we talk, but we don't do
anything. That night I dream
of my fathers out of Bohemia
filling the blue fields
of fresh and generous Ohio

with leaves and vines and orchards.
What my mother and I both know
is that we'd crawl with shame
in the emptiness we'd made
in our own and our fathers' backyard.
So the black walnut tree
swings through another year
of sun and leaping winds
of leaves and bounding fruit,
and, month after month, the whip-
crack of the mortgage.

Mary Oliver, 'The Black Walnut Tree'
Twelve Moons *(1979)*

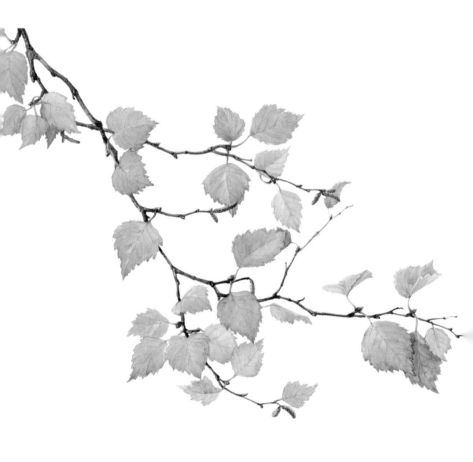

European Birch

The happy birch wood is a good place to wait for my day-bright girl; a place of quick paths, green tracks of a lovely colour, with a veil of shining leaves on the fine boughs; a sheltered place for my gold-clad lady, a lawful place for the thrush on the tree, a lovely place on the hillside, a place of green treetops, a place for two in spite of the cuckold's wrath; a concealing veil for a girl and her lover, full of fame is the greenwood; a place where the slender gentle girl, my love, will come to the leafy house made by God the Father. I have found for the building a kind of warden, the nightingale of glorious song under the greenwood, in his fine tawny dress in the leafy grove; a symbol of woodland delight, a forester always in the copse guarding the tree tops on the skirt of the slope. I shall make us a new room in the grove, fine and free, with a green top-storey of birches of lovely hue, and a summer-house and a fine bed, a parlour of the bright green trees, a glorious domain on the fringe of the green meadow. An enclosure of birches shall be maintained, with corner seats in the greenwood; a chapel of the lovely branches would not displease me, of the leaves of the green hazels, the mantles of May. The fine trees shall be a solace, a soot-free house for us today . . .

Dafydd ap Gwilym (fourteenth century), translated by K. Jackson

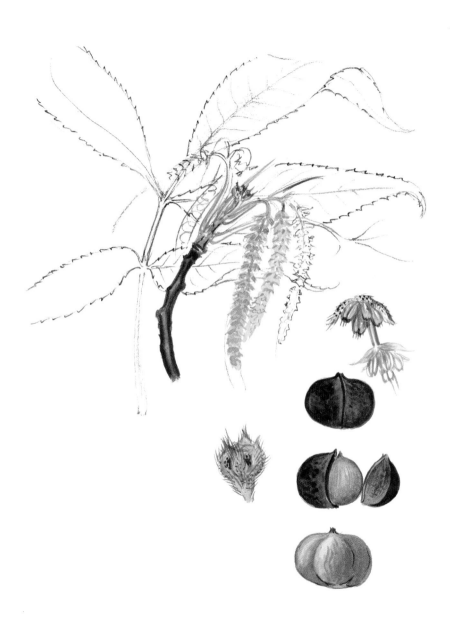

HICKORY

O helpless body of hickory tree,
What do I burn, in burning thee?
Summers of sun, winters of snow,
Springs full of sap's resistless flow;
All past year's joys of garnered fruits;
All this year's purposed buds and shoots;
Secrets of fields of upper air,
Secrets which stars and planets share;
Light of such smiles as broad skies fling;
Sounds of such tunes and wild winds sing;
Voices which told where gay birds dwelt,
Voices which told where lovers knelt; –
O strong white body of hickory tree,
How dare I burn all these, in thee?

Helen Hunt Jackson, 'My Hickory Fire' (1895)

GINKGO

Except for one mound with a clump of cherry-laurels overshadowed by a maiden-hair tree – whose skate-shaped leaves I used to give to my school friends to press between the pages of their atlases – the whole warm garden basked in a yellow light that shimmered into red and violet; but whether this red and violet sprang then, and still springs, from feelings of happiness or from dazzled sight, I could not tell.

Colette, Sido *(1929)*

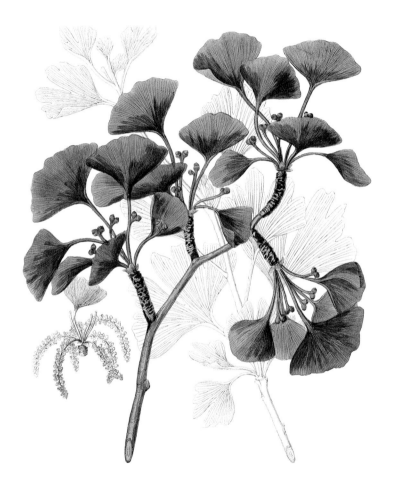

SWAMP CYPRESS

The *Cupressus disticha* stands in the first order or North American trees. Its majestic stature is surprising; and on approaching it, we are struck with a kind of awe, at beholding the stateliness of the trunk, lifting its cumbrous top toward the skies, and casting a wide shade upon the ground, as a dark intervening cloud, which, for a time, excludes the rays of the sun. The delicacy of its colour, and texture of its leaves, exceed everything in vegetation. It generally grows in the water, or in low flat lands, near the banks of great rivers and lakes, that are covered, great part of the year, with two or three feet depth of water; and that part of trunk which is subject to be under water, and four or five feet higher up, is greatly enlarged by prodigious buttresses, or pilaster, which, in full grown trees, project out on every side, to such a distance, that several men might easily hide themselves in the hollows between. Each pilaster terminates under ground, in a very large, strong, serpentine root, which strikes off, and branches every way, just under the surface of the earth: and from these roots grow woody cones, called cypress knees, four, five, and six inches high, and from six to eighteen inches and two feet in diameter at their bases. The large ones are hollow, and serve very well for bee-hives; a small space of the tree itself is hollow, nearly as high as the buttresses already mentioned. From this place the tree, as it were, takes another beginning, forming a grand straight column eighty or ninety feet high, when it divides every way around into an extensive flat horizontal top, like an umbrella, where eagles have their secure nests, and cranes and storks their temporary resting places; and what adds to the magnificence of their appearance is the streamers of long moss that hang from the lofty limbs and float in the winds. This is their majestic appearance when standing alone, in large rice plantation, or thinly planted on the banks of great rivers.

William Bartram, Travels *(1791)*

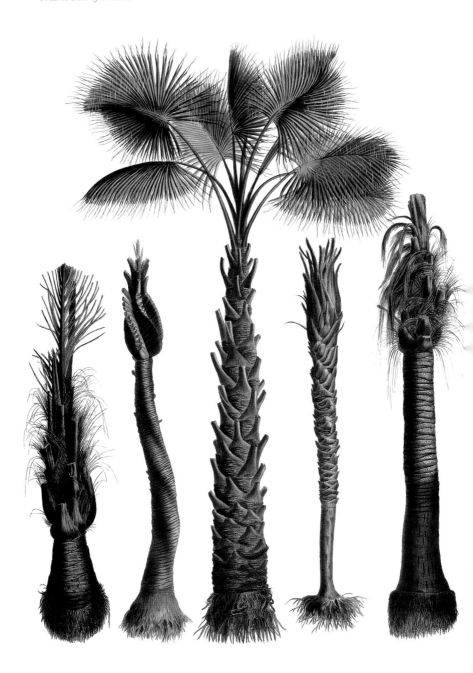

Palm

The palm at the end of the mind,
Beyond the last thought, rise
In the bronze distance.

A gold-feathered bird
Sings in the palm, without human meaning,
Without human feeling, a foreign song.

You know then that it is not the reason
That makes us happy or unhappy.
The bird sings. Its feathers shine.

The palm stands on the edge of space.
The wind moves slowly in the branches.
The bird's fire-fangled feathers dangle down.

Wallace Stevens, 'Of Mere Being', Opus Posthumous *(1957)*

HORSE CHESTNUT

Trim set in ancient sward, his manful bole
Upbore his frontage largely toward the sky.
We could not dream but that he had a soul:
What virtue breathed from out his bravery!

We gazed o'erhead: far down our deepening eyes
Rained glamours from his green midsummer mass.
The worth and sum of all his centuries
Suffused his mighty shadow on the grass.

A Presence large, a grave and steadfast Form
Amid the leaves' light play and fantasy,
A calmness conquered out of many a storm,
A Manhood mastered by a chestnut-tree!

Then, while his monarch fingers downward held
The rugged burrs wherewith his state was rife,
A voice of large authoritative Eld
Seemed uttering quickly parables of life:

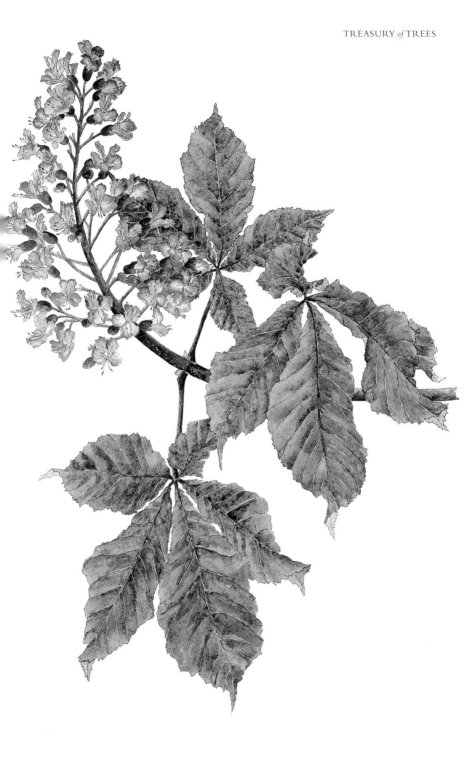

Horse chestnut (cont.)

'How Life in truth was sharply set with ills;
A kernel cased in quarrels; yea, a sphere
Of stings, and hedge-hog-round of mortal quills:
How most men itched to eat too soon i' the year,

'And took but wounds and worries for their pains,
Whereas the wise withheld their patient hands,
Nor plucked green pleasures till the sun and rains
And seasonable ripenings burst all bands

'And opened wide the liberal burrs of life.'
There, O my Friend, beneath the chestnut bough,
Gazing on thee immerged in modern strife,
I framed a prayer of fervency – that thou,

In soul and Stature larger than thy kind,
Still more to this strong Form might'st liken thee,
Till thy whole Self in every fibre find
The tranquil lordship of thy chestnut tree.

Sidney Lanier, 'Under the Cedarcroft Chestnut' (1877)

WHITE PINE

Strange that so few ever come to the woods to see how the pine lives and grows and spires, lifting its evergreen arms to the light, – to see its perfect success; but most are content to behold it in the shape of many broad boards brought to market, and deem that its true success! But the pine is no more lumber than man is, and to be made into boards and houses is no more its true and highest use than the truest use of man is to be cut down and made into manure. There is a higher law affecting our relation to pines as well as to men. A pine cut down, a dead pine, is no more a pine than a dead human carcass is a man. Can he who has discovered only some of the values of whalebone and whale oil be said to have discovered the true use of the whale? Can he who slays the elephant for his ivory be said to have 'seen the elephant'? These are petty and accidental uses; just as if a stronger race were to kill us in order to make buttons and flageolets of our bones; for everything may serve a lower as well as a higher use. Every creature is better alive than dead, men and moose and pine-trees, and he who understands it aright will rather preserve its life than destroy it.

Is it the lumberman, then, who is the friend and the

White pine (cont.)

lover of the pine, stands nearest to it, and understands its nature best? Is it the tanner who has barked it, or he who has boxed it for turpentine, whom posterity will fable to have changed into a pine at last? No! no! it is the poet; it is he who makes the truest use of the pine, – who does not fondle it with an axe, nor tickle it with a saw, nor stroke it with a plane, – who knows whether its heart is false without cutting into it, – who has not bought the stumpage of the township on which it stands. All the pines shudder and heave a sigh when that man steps on the forest floor. No, it is the poet, who loves them as his own shadow in the air, and lets them stand. I have been into the lumber-yard, and the carpenter's shop, and the tannery, and the lampblack-factory, and the turpentine clearing; but when at length I saw the tops of the pines waving and reflecting the light at a distance high over all the rest of the forest, I realized that the former were not the highest use of the pine. It is not their bones or hide or tallow that I love most. It is the living spirit of the tree, not its spirit of turpentine, with which I sympathize, and which heals my cuts. It is as immortal as I am, and perchance will go as high as heaven, there to tower above me still.

Henry David Thoreau, The Maine Woods *(1864)*

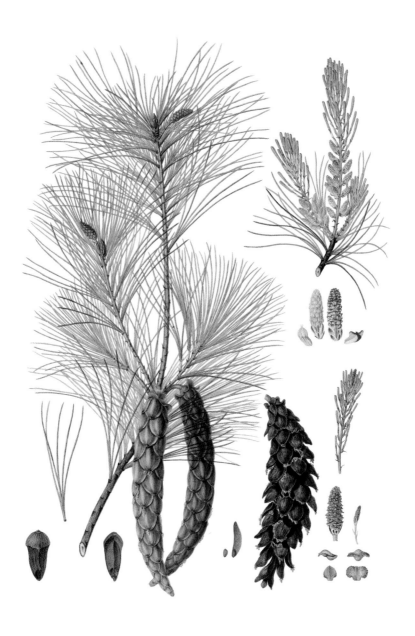

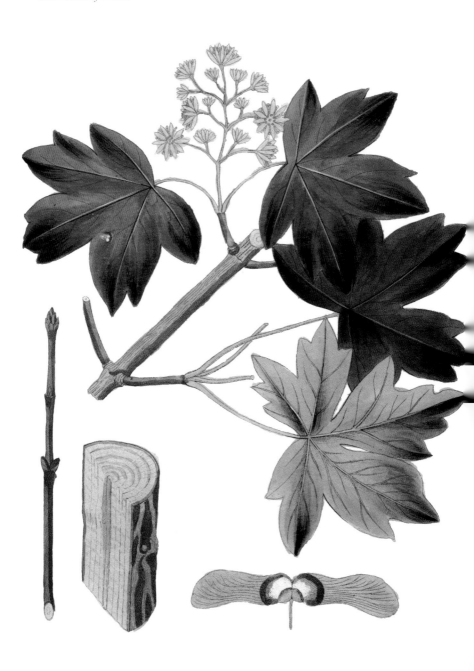

FIELD MAPLE

The Maple with its tassell flowers of green
That turns to red, a stag horn shapèd seed
Just spreading out its scallopped leaves is seen,
Of yellowish hue yet beautifully green.
Bark ribb'd like corderoy in seamy screed
That farther up the stem is smoother seen,
Where the white hemlock with white umbel flowers
Up each spread stoven to the branches towers
And mossy round the stoven spread dark green
The blotched leaved orchis and the blue bell flowers –
Thickly they grow and neath the leaves are seen.
I love to see them gemmed with morning hours.
I love the lone green places where they be
And the sweet clothing of the Maple tree.

John Clare, 'The Maple Tree' (c.1850s)

Black Spruce

Leaving [the ravine] at last, I began to work my way, scarcely less arduous than Satan's anciently through Chaos, up the nearest, though not the highest, peak. At first scrambling on all fours over the tops of ancient black spruce-trees (*Abies nigra* [*Picea mariana*]), old as the flood, from ten to twenty feet in height, their tops flat and spreading, and their foliage blue, and nipt with cold, as if for centuries they had ceased growing upwards against the bleak sky, the solid cold. I walked some good rods erect upon the tops of these trees, which were overgrown with moss and mountain-cranberries. It seemed that in the course of time they had filled up the intervals between the huge rocks, and the cold wind had uniformly levelled all over. Here the principle of vegetation was hard put to it. There was apparently a belt of this kind running quite round the mountain, though, perhaps, nowhere so remarkable as here. Once slumping through, I looked down ten feet, into a dark and cavernous region, and saw the stem of a spruce, on whose top I stood, as on a mass of coarse basket-work, full nine inches in diameter at the ground. These holes were bears' dens, and the bears were even then at home. This was the sort garden I made my way over for an eighth of a mile, at the risk, it is true, of treading on some of the plants, not seeing any path through it, – certainly the most treacherous and porous country I ever travelled.

Henry David Thoreau, The Maine Woods *(1864)*

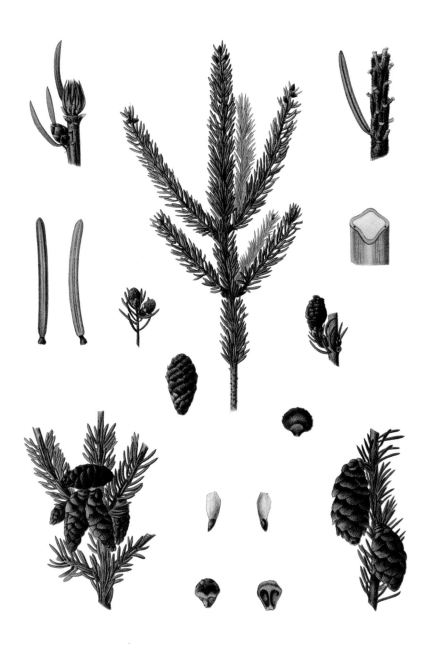

ENGLISH OAK

We came upon . . . what seemed at first in the dusk to be a great ruined grey tower, but which proved to be the vast ruin of the king oak of Moccas Park, hollow and broken but still alive and vigorous in parts and actually pushing out new shoots and branches. That tree may be 2000 years old. It measured roughly 33 feet round by arm stretching.

I fear those grey old men of Moccas, those grey, gnarled, low-browed, knock-kneed, bowed, bent, huge, strange, long-armed, deformed, hunchbacked, misshapen oak men that stand waiting and watching century after century, biding God's time with both feet in the grave and yet tiring down and seeing out generation after generation, with such tales to tell, as when they whisper to each other in the midsummer nights, make the silver birches weep and the poplars and aspens shiver and the long ears of the hares and rabbits stand on end. No human hand set those oaks. They are 'the trees which the Lord hath planted'. They look as if they had been at the beginning and the making of the world, and they will probably see its end.

Francis Kilvert, Kilvert's Diary, *Saturday 22 April 1876.*

English oak (cont.)

The Druids waved their golden knives
And danced around the Oak
When they had sacrificed a man;
But though the learned search and scan
No single modern person can
Entirely see the joke,
But though they cut the throats of men
They cut not down the tree,
And from the blood the saplings spring
Of oak-woods yet to be
But Ivywood, Lord Ivywood,
He rots the tree as ivy would,
He clings and crawls as ivy would
About the sacred tree.

King Charles he fled from Worcester fight
And hid him in the Oak;
In convent schools no man of tact
Would trace and praise his every act,
Or argue that he was in fact
A strict and sainted bloke.
But not by him the scared woods
Have lost their fancies free,
And though he was extremely big
He did not break the tree.
But Ivywood, Lord Ivywood
He breaks the tree as ivy would,
And eats the woods as ivy would
Between us and the sea.

Great Collingwood walked down the glade
And flung the acorns free,
That oaks might still be in the grove
As oaken as the beams above,
When the great Lover sailors love
Was kissed by Death at sea.
But though for him the oak-trees fell
To build the oaken ships,
The woodman worshipped what he smote
And honoured even the chips.
But Ivywood, Lord Ivywood,
He hates the tree as ivy would,
As the dragon of the ivy would
That has us in his grips.

> G. K. Chesterton, 'The Song of the Oak' (1914)

CEDAR OF LEBANON

There is none like her, none,
Nor will be when our summers have deceased.
O, art thou sighing for Lebanon
In the long breeze that streams to thy delicious East,
Sighing for Lebanon,
Dark cedar, tho' thy limbs have here increased,
Upon a pastoral slope as fair,
And looking to the South, and fed
With honey'd rain and delicate air,
And haunted by the starry head
Of her whose gentle will has changed my fate,
And made my life a perfumed altar-flame;
And over whom thy darkness must have spread
With such delight as theirs of old, thy great
Forefathers of the thornless garden, there
Shadowing the snow-limbed Eve from whom she came.

Alfred Lord Tennyson, 'Maud' (1855)

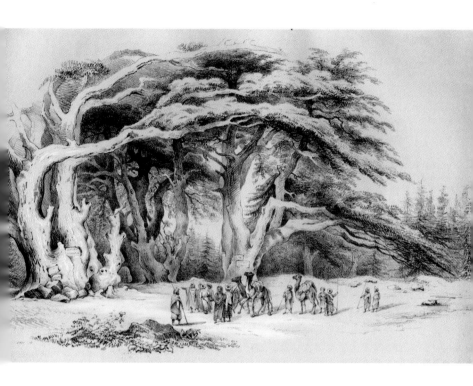

ASH

I was sitting by the side of a brook that runs down from the Comb, in which stands the village of Alford, through the grounds of Alfoxden. It was a chosen resort of mine. The brook fell down a sloping rock so as to make a waterfall considerable for that country, and across the pool below had fallen a tree, an ash if I rightly remember, from which rose perpendicularly, boughs in search of the light intercepted by the deep shade above. The boughs bore leaves of green that for want of sunshine had faded into almost lily-white; and from the underside of this natural sylvan bridge depended long and beautiful tresses of ivy which waved gently in the breeze that might poetically speaking be called the breath of the waterfall. This motion varied of course in proportion to the power of the water in the brook. When, with dear friends, I revisited this spot, after an interval of more than forty years, this interesting feature of the scene was gone. To the owner of the place I could not regret that the beauty of this retired part of the grounds had not tempted him to make it more accessible by a path, not broad or obtrusive, but sufficient for persons who love such scenes to creep along without difficulty.

William Wordsworth, Introduction to
'Lines Written in Early Spring', Lyrical Ballads *(1798)*

ALDER

For the bark, dulled argent, roundly wrapped
And pigeon-collared.
For the splitter-splatter, guttering
Rain-flirt leaves.
For the snub and clot of the first green cones,
Smelted emerald, chlorophyll.
For the scut and scat of cones in winter,
So rattle-skinned, so fossil-brittle.
For the alder-wood, flame-red when torn
Branch from branch.
But mostly for the swinging locks
Of yellow catkin,
Plant it, plant it,
Steel-head in the rain.

Seamus Heaney 'Planting the Alder',
District and Circle *(2006)*

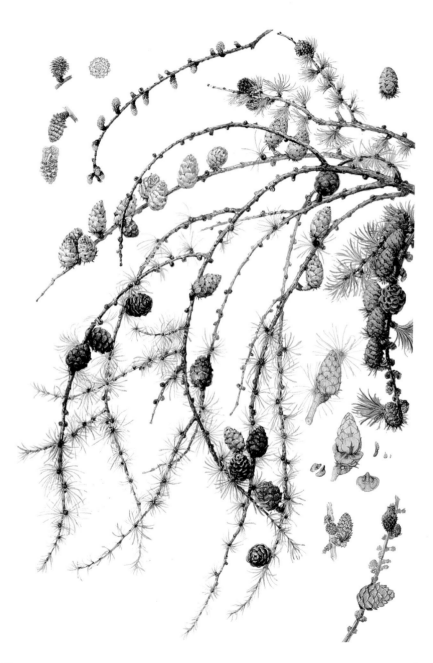

LARCH

Our selection of the larch may seem to some more disputable, but it will only be to such as are disposed to judge from outward show. We cannot, indeed, vindicate this valuable tree in so far as outward beauty is concerned: Wordsworth has condemned its formality at once, and its poverty of aspect. Planted in small patches, the tops of all the trees arising to the same height, and generally sloping in one direction from the prevailing wind, the larch-wood has, we must own, a mean and poor effect: its appearance on the ridge of a hill is also unfavourable, resembling the once fashionable mode of setting up the manes of ponies, called by jockeys hogging. But where the quantity of ground planted amounts to the character of a forest, the inequalities of the far-extended surface give to the larches a variety of outline which they do not possess when arranged in clumps and patches, and furnish that species of the sublime which all men must recognise in the prevalence of one tint of colouring in a great landscape. All who have seen the Swiss mountains, which are clothed with this tree as high as vegetation will permit, must allow that it can, in fitting situations, add effectually to the grandeur of Alpine scenery. In spring, too, the larch boasts, in an unequalled degree, that early and tender shade of green which is so agreeable to the eye, and suggests to the imagination the first and brightest ideas of reviving nature.

If, however, in spite of all that can be pleaded in its favour, the larch should be, in some degree, excluded from ornamental plantation, still the most prejudiced admirer of the picturesque cannot deny the right of this tree to predominate in those which are formed more for profit than beauty.

Sir Walter Scott, 'On Planting Waste Lands' (1827)

EUROPEAN BEECH

There is a little hill named Carne within the territorie of Tusculum not far from Roman Citie side, clad and beautiful with a goodly grove and tuft of beech trees, so even and round in the head as if they were curiously kept cut and shorne artificially with garden sheares. . . . In it there was one especiall faire tree above the rest, which Pabienus Crispus, a man in our daies of great authority . . . cast a fancie and extra ordinarie liking unto; insomuch as he was wont not only to take his repose and lie under it, to sprinkle and cast wine plentifully upon it, but also to clip, embrace and kisse it other whiles.

Pliny the Elder (first century BC)

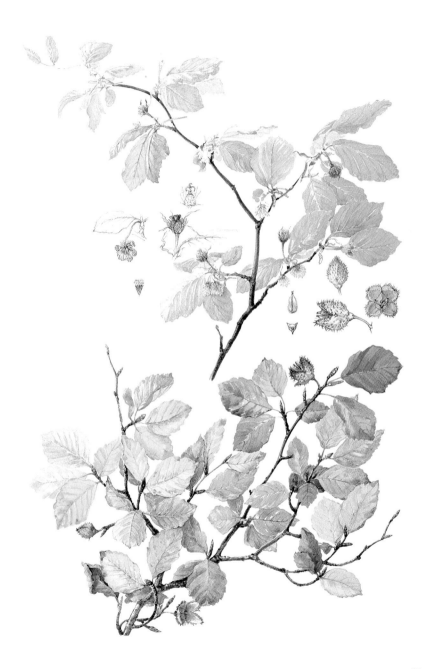

Aspen

My aspens dear, whose airy cages quelled,
Quelled or quenched in leaves the leaping sun,
All felled, felled, all are felled;
 Of a fresh and following folded rank
 Not spared, not one
 That dandled a sandalled
 Shadow that swam or sank
On meadow and river and wind-wandering weed-winding bank.

O if we knew what we do
 When we delve or hew –
Hack and rack the growing green!
 Since country is so tender
To touch her, being so slender,
That, like this sleek and seeing ball
But a prick will make no eye at all,
Where we, even when we mean
 to mend her we end her,
 When we hew or delve:
After-comers cannot guess the beauty been.
 Ten or twelve, only ten of twelve
 Strokes of havoc unselve
 The sweet especial scene
Rural scene, a rural scene
Sweet especial rural scene.

Gerard Manley Hopkins, 'Binsley Poplars, Felled 1879' (1879)

MIDLAND HAWTHORN

Let the only consistency
In the course of my poetry
Be like that of the hawthorn tree
Which in early spring breaks
Fresh emerald, then by nature's law
Darkens and deepens and takes
Tints of purple-maroon, rose-madder and straw.

Sometimes these hues are found
Together, in pleasing harmony bound.
Sometimes they succeed each other. But through
All the changes in which the hawthorn is dight,
No matter in what order, one thing is sure
– The haws shine ever the more ruddily bright!

And when the leaves have passed
Or only in a few tatters remain
The tree to the winter condemned
 Stands forth at last
 Not bare and drab and pitiful,
But a candelabrum of oxidized silver gemmed
By innumerable points of ruby
Which dominate the whole and are visible
Even at a considerable distance
As flame-points of living fire.
That so it may be
With my poems too at last glance
Is my only desire.

All else must be sacrificed to this great cause
I fear no hardships. I have counted the cost.

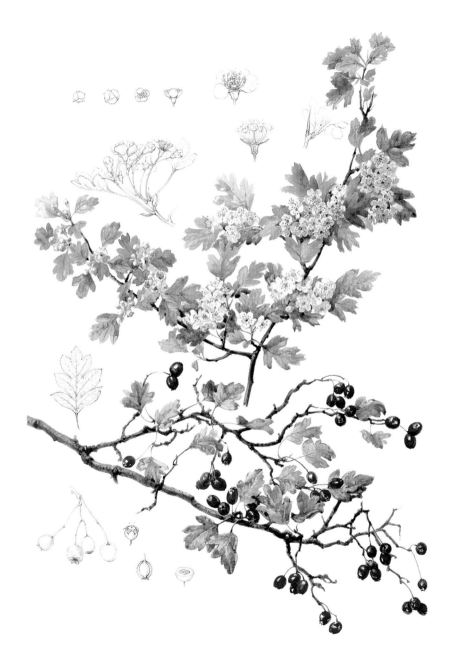

Midland hawthorn (cont.)

I with my heart's blood as the hawthorn with its haws
Which are sweetened and polished by the frost!
Blithe of heart, from week to week
Thou dost play at hide-and-seek;
While the patient primrose sits
Like a beggar in the cold,
Thou, a flower of wiser wits,
Slipp'st into thy sheltering hold;
Liveliest of the vernal train
When ye all are out again.

Drawn by what peculiar spell,
By what charm of sight or smell,
Does the dim-eyed curious Bee,
Labouring for her waxen cells,
Fondly settle upon Thee
Prized above all buds and bells
Opening daily at thy side,
By the season multiplied?

Thou art not beyond the moon,
But a thing 'beneath our shoon:'
Let the bold Discoverer thrid
In his bark the polar sea;
Rear who will a pyramid;
Praise it is enough for me,
If there be but three or four
Who will love my little Flower.

Hugh MacDiarmid (C. M. Grieve), 'In the Fall',
In Memoriam James Joyce *(1955)*

LOMBARDY POPLAR

So frail and slim, you, silvered by the moon
　　'Tis strange what memory comes stalking back:
A tortured road in France, tree-bordered, black
　　With smoke that stained the loveliness of June.

James McBride Dabbs, 'To a Lombardy Poplar' (1923)

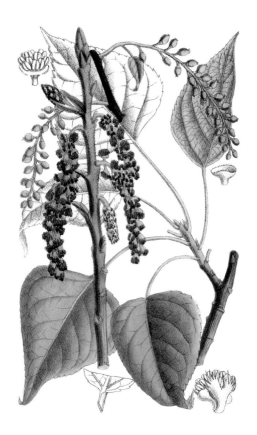

Cabbage Tree

As the Cotton is the biggest tree in the Woods, so the Cabbage-tree is the tallest: The Body is not very big, but very high and strait. I have measured one in the Bay of Campeachy 120 feet long as it lay on the Ground, and there are some much higher. It has no Limbs nor Boughs, but at the head there are many Branches bigger than a Man's Arm. These Branches are not covered, but flat, with sharp edges; they are 12 or 14 foot long. About two foot from the Trunk, the Branches shoot forth small long Leaves, about an Inch broad, which grow so regularly on both sides of the Branch, that the whole Branch seems to be but one Leaf, made up of many small ones. The Cabbage Fruit shoots out in the midst of these Branches, from the top of the Tree; it is invested with many young Leaves or Branches which are ready to spread abroad, as the old Branches drop and fall down. The Cabbage itself, when it is taken out of the Leaves which it seems to be folded in, is as big as the small of a Man's Leg, and a foot long; it is white as Milk, and as sweet as a Nut, if eaten raw, and it is very sweet and wholesom if boiled. Besides the Cabbage it self, there grow out between the Cabbage and the large Branches, small Twigs, as of a Shrub, about two foot long from their Stump. At the end of those Twigs (which grow very thick together) there hang Berries hard and round, and as big as a Cherry. These the Tree sheds every year, and they are very good for Hogs: for this reason the Spaniards fine any who shall cut down any of these in their Woods. The body of the Tree is full of rings round it, half a foot asunder from the Bottom to the top. The Bark is think and brittle; the Wood is black and very hard, the heart or middle of the Tree is white

Pith. They do not climb to get the Cabbage, but cut them down; for should they gather off the Tree as it stands, yet its head being gone, it soon dies. These Trees are much used by Planters in Jamaica, to board the sides of the Houses, for it is but splitting the Trunk into four parts with an Axe, and there are so many Planks. Those Trees appear very pleasant, and they beautifie the whole Wood, spreading their green Branches above the other Trees.

William Dampier, A New Voyage Round the World *(1697)*

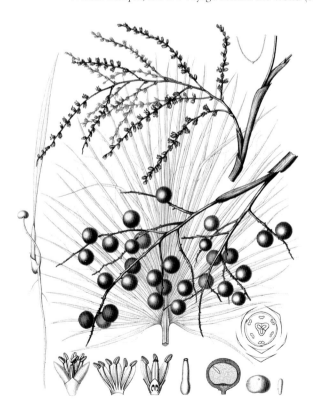

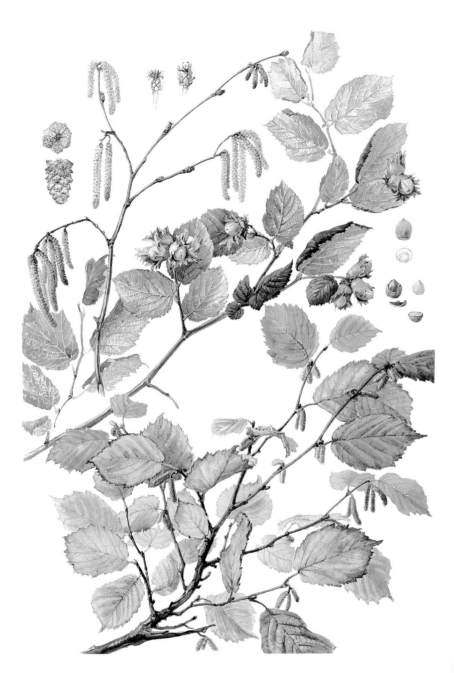

HAZEL

I went out to the hazel wood,
Because a fire was in my head,
And cut and peeled a hazel wand,
And hooked a berry to a thread;
And when white moths were on the wing,
And moth-like stars were flickering out,
I dropped the berry in a stream
And caught a little silver trout.

When I had laid it on the floor
I went to blow the fire aflame,
But something rustled on the floor,
And someone called me by my name:
It had become a glimmering girl
With apple blossoms in her hair
Who called me by my name and ran
And faded through the brightening air.

Though I am old with wandering
Through hollow lands and hilly lands,
I will find out where she has gone,
And kiss her lips and take her hands;
And walk among long dappled grass,
And pluck till time and times are done
The silver apples of the moon,
The golden apples of the sun.

William Butler Yeats, 'The Song of Wandering Aengus',
The Wind Among the Reeds *(1899)*

JAPANESE MAPLE

Amongst the odd plants was one large *Acer palmatum*. Having many other things to deal with, I shirked this part of the garden for several seasons until, finally, its turn had to come. The first thing to do was to clear away all the indiscriminate shrub planting and leave only the trees. This done, I saw that I had gained a sense of space but that the site lacked coherence, and that I still had an unlovely grass slope with a few haphazard trees. To change the contours and levels would have led to costly and unnecessary complications, so that I could only save the situation by imposing some planting theme which by its unity would dominate the site. As the slope lay not far from the house I did not want to close in the view by planting more conifers or rhododendrons, and rather than invent some arbitrary solution I looked at the site again and again, hoping that something already present would indicate a theme and give me a starting point. This something turned out to be the one Japanese maple which grew out of sight, hidden behind a large thujopsis. Starting a little timidly, I planted twelve more red-leaved *Acer palmatum* in all the open spaces on the upper part of the bank. When this was done I had a large enough sample to see that these trees, if I planted enough of them, would grow into a semi-transparent veil of reddish foliage which would give character to the site and be interesting enough

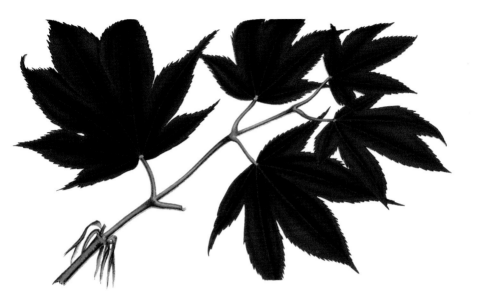

in itself to distract the eye from the rather awkward lie of the land. In the end I planted three dozen more maples of the same variety which fill all the awkward spaces and continue out and downwards to make a large planting, spreading on to the open lawn below. After the flowers are all gone, the reddish bracts remain for a bit, and the foliage of the plant itself often (almost always) turns to rich bronze and red. So even when the fall turns cold the plant is handsome in its modest way, which is the best way for anything to be handsome, as we know.

Russell Page, The Education of a Gardener *(1962)*

WHITE OAK

Pray why are you so bare, so bare,
 Oh bough of the old oak-tree;
And why, when I go through the shade you throw,
 Runs a shudder over me?

My leaves were green as the best, I trow,
 And sap ran free in my veins,
But I saw in the moonlight dim and weird
 A guiltless victim's pains.

I bent me down to hear his sigh;
 I shook with his gurgling moan,
And I trembled sore when they rode away,
 And left him here alone.

They'd charged him with the old, old crime,
 And set him fast in jail:
Oh, why does the dog howl all night long,
 And why does the night wind wail?

He prayed his prayer and he swore his oath,
 And he raised his hand to the sky;
But the beat of hoofs smote on his ear,
 And the steady tread drew night.

Who is it rides by night, by night.
 Over the moonlit road?
And what is the spur that keeps the pace,
 What is the galling goad?

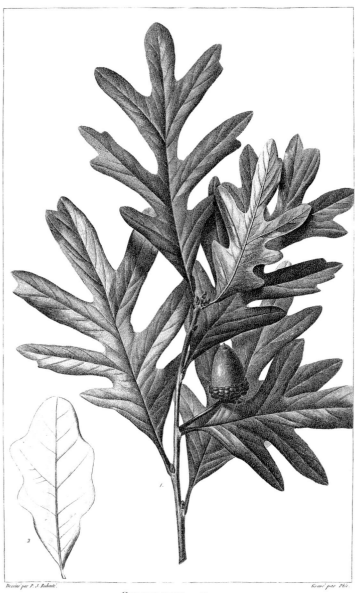

Dessiné par P. J. Redouté. Gravé par Plée.

QUERCUS alba : *1. pinnatifida .*
2. repanda

White oak (cont.)

And now they beat the prison door,
 'Ho, keeper, do not stay!
We are friends of him whom you hold within,
 And we fain would take him away

'From those who ride fast on our heels
 With mind to do him wrong;
They have no care for his innocence,
 And the rope they bear is long.'

They have fooled the jailer with lying words,
 They have fooled the man with lies;
The bolts unbar, the locks are drawn,
 And the great door open flies.

Now they have taken him from the jail,
 And hard and fast they ride,
The leader laughs down in his throat,
 As they halt my trunk beside.

Oh, the judge, he wore a mask of black,
 And the doctor one of white,
And the minister, with his oldest son,
 Was curiously bedight.

Oh, foolish man, why weep you now?
 'Tis but a little space,
And the time will come when these shall dread
 The mem'ry of your face.

I feel the rope against my bark,
 And the weight of him in my grain,
I feel the throe of his final woe
 The touch of my own last pain.

And never more shall leaves come forth
 On the bough that bears the ban;
I am burned with dread, I am dried and dead,
 From the curse of a guiltless man.

And ever the judge rides by, rides by,
 And goes to hunt the deer,
And ever another rides his soul
 In the guise of a mortal fear.

And ever the man he rides me hard,
 And never a night stays he;
For I feel his curse as a haunted bough,
 On the trunk of a haunted tree.

Paul Laurence Dunbar, 'The Haunted Oak'
Love and Laughter *(1903)*

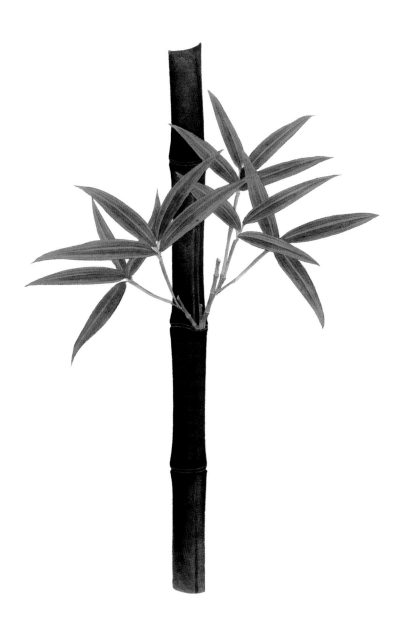

BAMBOO

I am not suited for service in a country town;
At my closed door autumn grasses grow.
What could I do to ease a rustic heart?
I planted bamboos, more than a hundred shoots.
When I see their beauty, as they grow by the stream-side,
I feel again as though I lived in the hills,
And many a time when I have not much work
Round their railing I walk until night comes.
Do not say that their roots are still weak,
Do not say that their shade is still small;
Already I feel that both in courtyard and house
Day by day a fresher air moves.
But most I love, lying near the window-side,
To hear in their branches the sound of the autumn wind.

Po Chü-I (806), translated by Arthur Waley

BANYAN

O you shaggy-headed banyan tree standing on the bank of the pond, have you forgotten the little child, like the birds that have nested in your branches and left you?

Do you not remember how he sat at the window and wondered at the tangle of your roots that plunged underground?

The women would come to fill their jars in the pond, and your huge black shadow would wriggle on the water like sleep struggling to wake up.

Sunlight danced on the ripples like restless tiny shuttles weaving golden tapestry.

Two ducks swam by the weedy margin above their shadows, and the child would sit still and think.

He longed to be the wind and blow through your resting branches, to be your shadow and lengthen with the day on the water, to be a bird and perch on your topmost twig, and to float like those ducks among the weeds and the shadows.

Rabindranath Tagore, 'The Banyan Tree' (1913)

MONKEY PUZZLE

Tree of the don't come near, reserve,
it is better so. Tree of the gesture
on a deserted beach, tree of the unforgettable,
of the tiled roof and teapot in the pantry window,
tree of the private greenhouse, of the new haircut,
the sculpture garden,
of confusion and response,
of the car ride, tree of the stick pin.

Talvikki Ansel, 'Tree List, or Stay Again, Blue Collection' (2003)

CHESTNUT

From bristly foliage
you fell
complete,
polished wood,
gleaming mahogany,
as perfect
as a violin newly
born of the treetops,
that falling
offers its sealed-in gifts,
the hidden sweetness
that grew in secret
amid birds and leaves,
a model of form,
kin to wood and flower,
an oval instrument
that holds within it
intact delight, an edible rose.
In the heights you abandoned
the sea-urchin burr
that parted its spines
in the light of the chestnut tree;
through that slit

you glimpsed the world,
birds
bursting with syllables,
starry
dew,
below,
the heads of boys
and girls,
grasses stirring restlessly,
smoke rising, rising.
You made your decision,
chestnut,
and leaped to earth,
burnished and ready,
firm and smooth
as the small breasts
of the islands of America.
You fell,
you struck
the ground,
but
nothing happened,
the grass

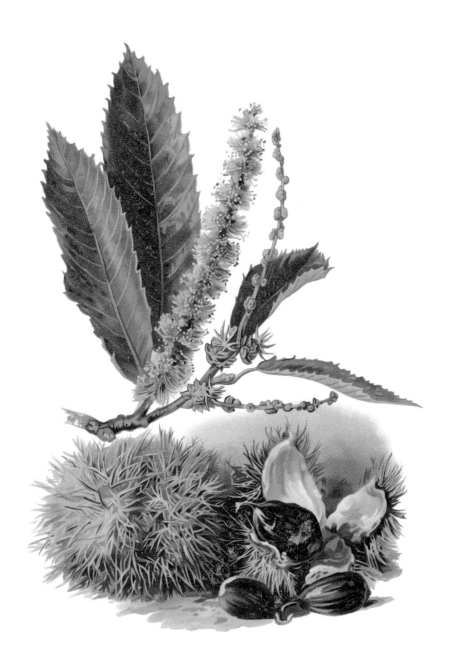

Chestnut (cont.)

still stirred, the old
chestnut sighed with the mouths
of a forest of trees,
a red leaf of autumn fell,
resolutely, the hours marched on
across the earth.
Because you are
only
a seed,
chestnut tree, autumn, earth,
water, heights, silence
prepared the germ,
the floury density,
the maternal eyelids
that buried will again
open towards the heights
the simple majesty
of foliage,
the dark damp plan
of new roots,
the ancient but new dimensions
of another chestnut tree in the earth.

Pablo Neruda, 'Ode to a Chestnut on the Ground',
Odas Elementales (1954), translated by
Margaret Sayers Peden

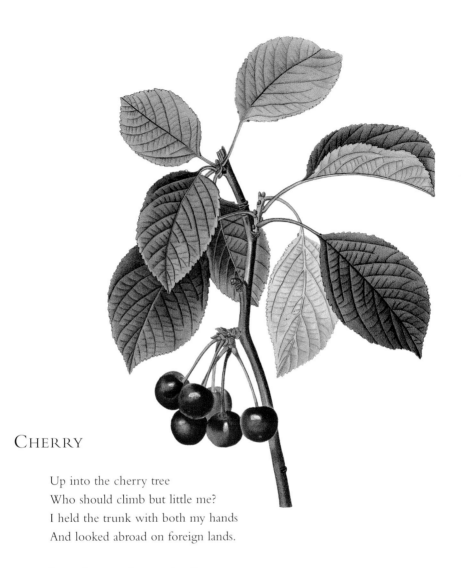

CHERRY

Up into the cherry tree
Who should climb but little me?
I held the trunk with both my hands
And looked abroad on foreign lands.

I saw the next door garden lie
Adorned with flowers before my eye,
And many pleasant places more
That I had never seen before.

Robert Louis Stevenson, 'Foreign Lands'
A Child's Garden of Verses *(1885)*

SUGAR PINE

Of all the world's eighty or ninety species of pine trees, the Sugar Pine (*Pinus lambertiana*) is king, surpassing all other, not merely in size but in lordly beauty and majesty. . . . The trunk is a remarkably smooth, round, delicately-tapered shaft, straight and regular as if turned in a lathe, mostly without limbs, purplish brown in color and usually enlivened with tufts of yellow lichen. Toward the head of this magnificent column long branches sweep gracefully outward and downward, sometimes forming a palm-like crown, but far more impressive than any palm crown I ever beheld. The needles are about three inches long in fascicles of five, and arranged in rather close tassels at the ends of slender branchlets that clothe the long outsweeping limbs. How well they sing in the wind, and how strikingly harmonious an effect is made by the long cylindrical cones, depending loosely from the ends of the long branches! The cones are about fifteen to eighteen inches long, and three in diameter; green, shaded with dark purple on their sunward sides. They are ripe in September and October of the second year from the flower. Then the flat, thin scales open and the seeds take wing, but the empty cones become still more beautiful and effective as decorations, for their diameter is nearly doubled by the spreading of the scales, and their color changes to yellowish brown while they remain, swinging on the tree all

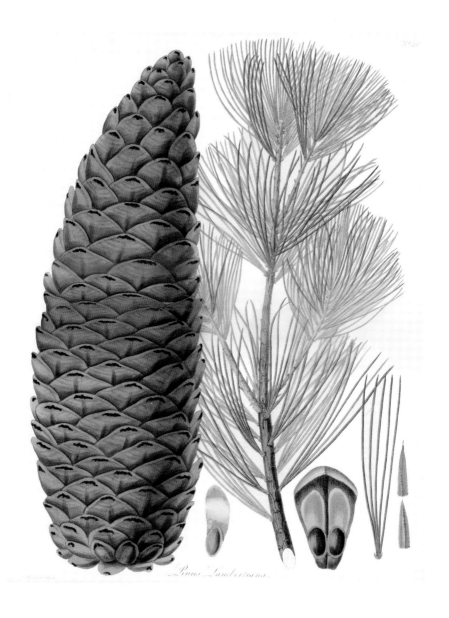

Pinus Lambertiana.

Sugar pine (cont.)

the following winter and summer, and continue beautiful even on the ground many years after they fall. The wood is deliciously fragrant, fine in grain and texture and creamy yellow, as if formed of condensed sunbeams. . . . No tree lover will ever forget his first meeting with the sugar pine. In most pine trees there is the sameness of expression which to most people is apt to become monotonous, for the typical spiral form of conifers, however beautiful, affords little scope for appreciable individual character. The sugar pine is as free from conventionalities as the most picturesque oaks. No two are alike, and though they toss out their immense arms in what might seem extravagant gestures they never lose their expression of serene majesty. They are the priests of the pines and seem ever to be addressing the surrounding forest.

John Muir, The Yosemite *(1912)*

Holm Oak

The Ilex or Ever-green Oak, is a Tree that deservedly stands in Front of all the Ever-greens, both for its Beauty and Usefulness. But because there have been already so many Mistakes made, and so many Disappointments undergone with respect to the Kind and Management of this Tree, I have the Pleasure to let the World know from whence those Mistakes came, and how to prevent future Disappointments. The Secret I had from a Friend, who was well informed thereof by a Correspondent in Italy, who assures us, that there are two sorts of Ilex, viz. the Tree, and the Dwarf-Ilex; both of them well known in Italy, by that distinction. And altho' they are exactly alike in Shape and Colour, when they are young, yet it is well known that the Tree-Ilex, will not easily be made into a Dwarf, and the Dwarf-Ilex, can never be made a Tree, but is always intended and kept for Espaliers. It is the last of these whose Seed we commonly receive from Italy and Spain, and there have been very few of the former sort ever yet sent over, as imagining that we want Espaliers, and not Timber. Mr Balle in Devonshire, and some few others have been so fortunate as to light upon the large sort, and manage even that according to the Rules of Art, by either letting them stand Holding the Seed-Plot, without a remove, or if they are remov'd, to do it with the

Holm oak (cont.)

utmost Care and Caution, not hurting or shortning the Tap-root: But as far as I can find, it is the general Complaint, that the Ilex here proves a Dwarf-Tree; And for what reason, let it be judg'd by what hath been said above.

However, after such a Caution as this, it is easie to direct that the Seed be pluck't from the large Trees, and not from Dwarfs, when a demand is made, or to get them from some of those large Trees now in Devonshire, raised from the Acorns, set in well sifted Loam; and not removed if possible, but with all the Root and Earth about them. Thus managed and rightly chosen, it is a Tree of very quick growth, vastly beautiful and very profitable.

John Laurence, A New System of Agriculture *(1726)*

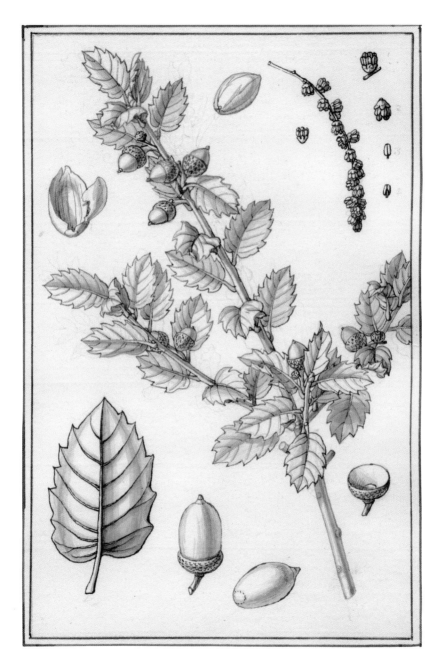

MULBERRY

God in the whizzing of a pleasant wind
Shall march upon the tops of mulberry trees.

George Peele, David and Fair Bathsabe (1599)

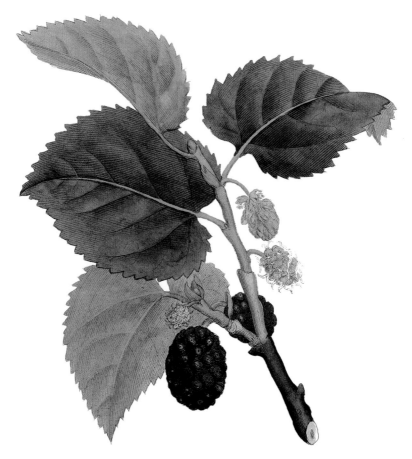

The mulberry is a double tree.
Mulberry shade me, shade me awhile.

A white, pink, purple berry tree,
A very dark-leaved berry tree
Mulberry shade me, shade me awhile.

A churchyard kind of a bush as well,
A silent sort of a bush, as well.
Mulberry shade me, shade me awhile.

It is a shape of life described
By another shape without a word.
Mulberry shade me, shade me awhile –

With nothing fixed by a single word.
Mulberry shade me, shade me awhile.

Wallace Stevens, 'Banjo Boomer', Opus Posthumous *(1957)*

Incense Cedar

The incense cedar (*Libocedrus decurrens*) with cinnamon-colored bark and yellow-green foliage is one of the most interesting of Yosemite trees. Some of them are 150 feet high, from six to ten feet in diameter, and they are never out of sight as you saunter among the yellow pines. Their bright brown shafts and towers of flat, frond-like branches make a striking feature of the landscapes throughout all the seasons. In midwinter, when most other trees are asleep, this cedar puts forth its flowers in millions, – the pistillate pale green and inconspicuous, but the staminate bright yellow, tingeing all the branches and making the trees as they stand in the snow look like gigantic goldenrods. The branches, outspread in flat plumes and beautifully fronded, sweep gracefully downward and outward, except those near the top, which aspire; the lowest, especially in youth and middle age, droop to the ground, overlapping one another, shedding off rain and snow like shingles, and making fine tents for birds and campers. This tree frequently lives more than a thousand years and is well worthy of its place beside the great pines and the Douglas spruce.

John Muir, The Yosemite *(1912)*

BONSAI

Another example will show the passion which exists among the Chinese for things of this kind. When I was travelling on the hills of Hong-kong, a few days after my first arrival in China, I met with a most curious dwarf *Lycopodium* [*L. clavatum* or *L. complanatum*], which I dug up and carried down to Messrs. Dent's garden, where my other plants were at the time. 'Hai-yah,' said the old compradore, when he saw it, and was quite in raptures of delight. All the other coolies and servants gathered round the basket to admire this curious little plant. I had not seen them evince so much gratification since I showed them the 'old man Cactus' (*Cereus senilis*), which I took out from England, and presented to a Chinese nurseryman at Canton. On asking them why they prized the Lycopodium so much, they replied, in Canton English, 'Oh, he be too muchia handsome; he grow only a leete and a leete every year; and suppose he be one hundred year oula, he only so high,' holding up their hands an inch or two higher than the plant. This little plant is really very pretty, and often takes the very form of a dwarf tree in miniature, which is doubtless the reason of its being such a favorite with the Chinese.

Robert Fortune, Three Years' Wanderings in the
Northern Provinces of China *(1847)*

PAPER BIRCH

When I see birches bend to left and right
Across the line of straighter darker trees,
I like to think some boy's been swinging them.
But swinging doesn't bend them down to stay.
Ice-storms do that. Often you must have seen them
Loaded with ice on a sunny winter morning
After a rain. They click upon themselves
As the breeze rises, and turn many-colored
As the stir cracks and crazes their enamel.
Soon the sun's warmth makes them shed crystal shells
Shattering and avalanching on the snow-crust –
Such heaps of broken glass to sweep away
You'd think the inner dome of heaven had fallen.
They are dragged to the withered bracken by the load,
And they seem not to break; though once they are bowed
So low for long, they never right themselves:
You may see their trunks arching in the woods
Years afterwards, trailing their leaves on the ground
Like girls on hands and knees that throw their hair
Before them over their heads to dry in the sun.
But I was going to say when Truth broke in
With all her matter-of-fact about the ice-storm
(Now am I free to be poetical?)
I would prefer to have some boy bend them
As he went out and in to fetch the cows –
Some boy too far from town to learn baseball,
Whose only play was what he found himself,
Summer or winter, and could play alone.
One by one he subdued his father's trees
By riding them down over and over again
Until he took the stiffness out of them

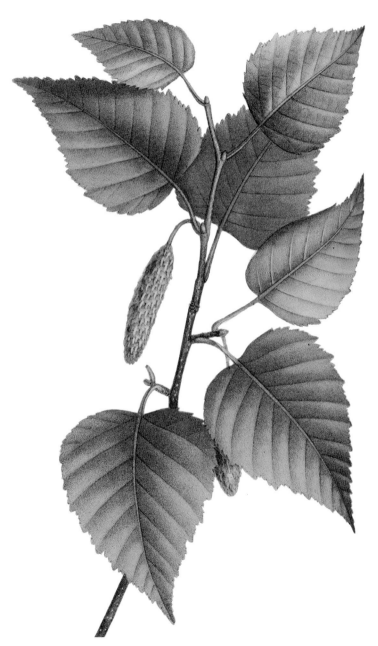

Paper birch (cont.)

And not one but hung limp, not one was left
For him to conquer. He learned all there was
To learn about not launching out too soon
And so not carrying the tree away
Clear to the ground. He always kept his poise
To the top branches, climbing carefully
With the same pains you use to fill a cup
Up to the brim, and even above the brim.
Then he flung himself, feet first, with a swish,
Kicking his way down through the air to the ground.
So I was once myself a swinger of birches.
And so I dream of going back to be.
It's when I'm weary of considerations,
And life is too much like a pathless wood
Where your face burns and tickles with the cobwebs
Broken across it, and one eye is weeping
From a twig's having lashed across it open.
I'd like to get away from earth awhile
And then come back to it and begin over.
May no fate willfully misunderstand me
And half grant what I wish and snatch me away
Not to return. Earth's the right place for love:
I don't know where it's likely to go better.
I'd like to go by climbing a birch tree,
And climb black branches up a snow-white trunk
Toward heaven, till the tree could bear no more,
But dipped its top and set me down again.
That would be good both going and coming back
One could do worse than be a swinger of birches.

Robert Frost, 'Birches', Mountain Interval *(1920)*

Scots Pine

Hail to the chief who in triumph advances!
 Honour'd and blesse'd be the evergreen Pine!
Long may the tree, in his banner that glances,
 Flourish, the shelter and grace of our line!
 Heaven send it happy dew,
 Earth lend it sap anew,
Gaily to burgeon, and broadly to grow,
 While every Highland glen
 Sends our shout back again,
'Roderigh Vich Alpine dhu, ho! ieroe!'

Sir Walter Scott, 'A Highland Boat Song', Lady of the Lake *(1810)*

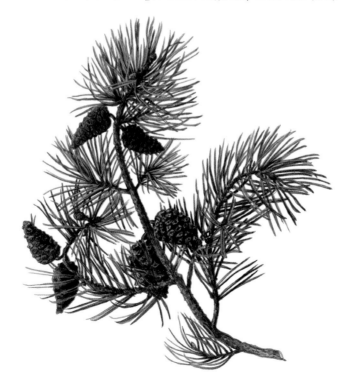

MOOSEWOOD

Getting up some time after midnight to collect the scattered brands together, while my companions were sound asleep, I observed, partly in the fire, which had ceased to blaze, a perfectly regular elliptical ring of light, about five inches in its shortest diameter, six or seven in its longer, and from one eighth to one quarter of an inch wide. It was fully as bright as the fire, but not reddish or scarlet like a coal, but a white and slumbering light, like the glowworm's. I could tell it from the fire only by its whiteness. I saw at once that it must be phosphorescent wood, which I had so often heard of, but never chanced to see. Putting my finger on it, with a little hesitation, I found that it was a piece of dead moose-wood (*Acer striatum*) which the Indian had cut off in a slanting direction the evening before. Using my knife, I discovered that the light proceeded from that portion of the sap-wood immediately under the bark, and thus presented a regular ring at the end, which, indeed, appeared raised above the level of the wood, and when I pared off the bark and cut into the sap, it was aglow all along the log. I was surprised to find the wood quite hard and apparently sound, though perhaps decay had commenced in the sap, and I cut out some little triangular chips, and placing them in the hollow of my hand, carried them into the camp, waked my companion, and showed them to him. They lit up the inside of my hand, revealing the lines and wrinkles, and appearing exactly like coals of fire raised to a white heat, and I saw at once how, probably, the Indian jugglers had imposed on their people and on travellers, pretending to hold coals of fire in their mouths. . . . I was exceedingly interested by this phenomenon, and already felt paid for my journey. It could hardly have thrilled me more if it had taken the form of letters, or the human face. If I had met with this ring of light while groping in the forest alone, away from any fire, I should have been still more surprised. I little thought that there was such a light shining in the darkness of the wilderness for me.

Henry David Thoreau, The Maine Woods *(1864)*

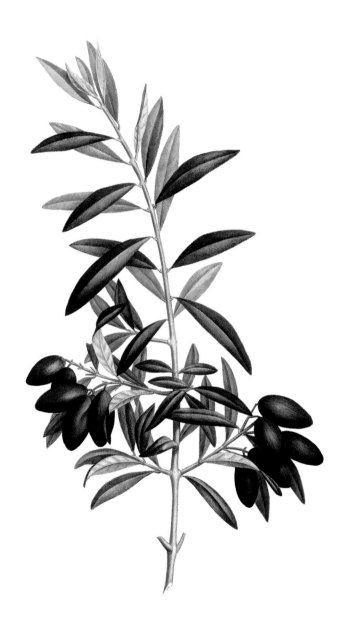

OLIVE

Save for a lustreless honing-stone of moon
The sky stretches its flawless canopy
Blue as the blue silk of the Jewish flag
Over the valley and out to sea.
It is bluest just above the olive tree.
You cannot find in twisted Italy
So straight a one; it stands not on a crag,
It is not humpbacked with bearing in scored stone,
But perfectly erect in my front yard,
Oblivious of its fame. The fruit is hard,
Multudinous, acid, tight on the stem;
The leaves ride boat-like in the brimming sun.
Going nowhere and scooping up the light.
It is the silver tree, the holy tree,
Tree of all attributes.

Now on the lawn
The olives fall by thousands, and I delight
To shed my tennis shoes and walk on them,
Pressing them coldly into the deep grass,
In love and reverence for the total loss.

Karl Shapiro, 'The Olive Tree', Poems of a Jew (1958)

CALABASH

Sublime calabassia, luxuriant tree!
How soft the gloom they bright-lined foliage throws,
While from thy pulp a healing balsam flows,
Whose power the suffering wretch from pain can free!
My pensive footsteps ever turn to thee!
Since oft, while musing on my lasting woes,
Beneath thy flowery white bells I repose,
Symbol of friendship dost thou seem to me;
For thus has friendship cast her soothing shade
O'er my unsheltered bosom's keen distress:
Thus sought to heal the wounds which love has made,
And temper bleeding sorrow's sharp excess!
Ah! not in vain she lends her balmy aid:
The agonies she cannot cure, are less!

Jacques-Henri Bernardin de St Pierre,
'To the Calbassia Tree',
Paul et Virginie *(1787)*

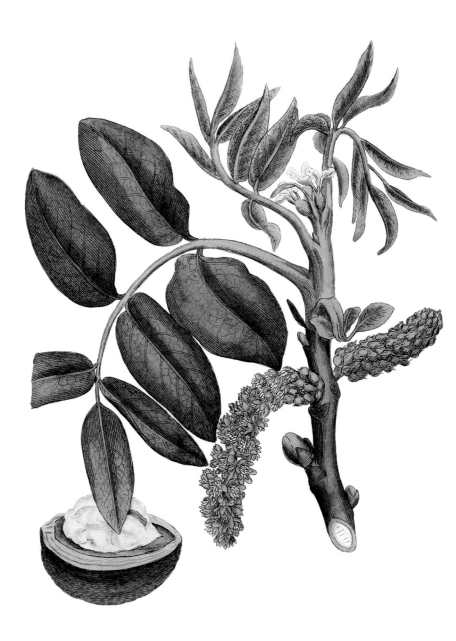

WALNUT

Their outward husk serveth to die wooll, and the little nuts when they come new fourth, are good to give the hairs of the head a reddish or yellow colour; the experiment thereof was first found, by staining folks hands as they handled them. The elder that nuts be and longer kept, the more oleous and fatter they are. The onely difference of the sundrie kinds, consisteth in the shell, for that of some it is tender and brittle, in others hard; in one sort it is thin, in another thicke; lastly, some have smooth and plaine shells, others againe be as full of holes and cranies. Walnuts be the fruit alone that Nature hath enclosed with a cover parted in twaine, for it is joined and set together; for the shell is divided and cleft just in the mids, and each halfe resembleth a little boat. The kernel within is distinguished into foure parts, and between every one there runneth a membrane or skin of a woodie substance.

Pliny the Elder (first century BC)

WELLINGTONIA

So harmonious and finely balanced are even the mightiest of these monarchs in all of their proportions that there is never anything overgrown or monstrous about them. Seeing them for the first time you are more impressed with their beauty than their size, their grandeur being in great part invisible; but sooner or later it becomes manifest to the loving eye, stealing slowly on the senses like the grandeur of Niagara or the Yosemite Domes. When you approach them and walk around them you begin to wonder at their colossal size and try to measure them. They bulge considerably at base, but not more than is required for beauty and safety and the only reason that this bulging seems in some cases excessive is that only a comparatively small section is seen in near views. One that measured in the Kings River forest was twenty-five feet in diameter at the ground and ten feet in diameter 220 feet above the ground showing the fineness of the taper of the trunk as a whole. No description can give anything like an adequate idea of their singular majesty, much less of their beauty. Except the sugar pine, most of their neighbors with pointed tops seem ever trying to go higher, while the big tree, soaring above them all, seems satisfied. Its grand domed head seems to be poised about as lightly as a cloud, giving no impression of seeking to rise higher. Only when it is young does it show like other conifers a heavenward yearning, sharply aspiring with a long quick-growing top. Indeed, the whole tree for the first century or two, or until it is a hundred or one hundred and fifty feet high, is arrowhead in form, and, compared with the solemn rigidity of age seems as sensitive to the wind as a squirrel's tail. As it grows older, the lower branches are gradually dropped and the upper ones thinned out until comparatively few are left. These, however, are developed to a great size, divide again and again and terminate in bossy, rounded masses of leafy branchlets, while the head become dome-shaped, and is the first to feel the touch of the rosy beams of the morning, the last to bid the sun good night. . . . Except in picturesque old age, after being struck by lightning or broken by thousands of snowstorms, the regularity of forms is one of their most distinguishing characteristics. Another is the simple beauty of the trunk and its great

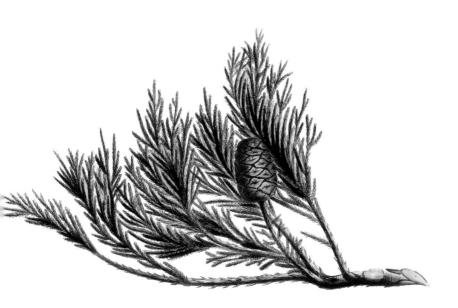

thickness as compared to the height and width of the branches, which make them look more like finely modeled and sculptured architectural columns than the stems of trees, while the great limbs look like rafters, supporting the magnificent dome-head. But though so consummately beautiful, the big tree always seems unfamiliar, with peculiar physiognomy, awfully solemn and earnest; yet with all its strangeness it impresses us as being more at home than any of its neighbors, holding the best right to the ground as the oldest strongest inhabitant. One soon becomes acquainted with new species of pine and fir and spruce as with friendly people, shaking their outstretched branches like shaking hands and fondling their little ones, while the venerable aboriginal sequoia, ancient of their days, keeps you at a distance, looking as strange in aspect and behavior among its neighbor trees as would the mastodon among the homely bears and deer.

John Muir, The Yosemite *(1912)*

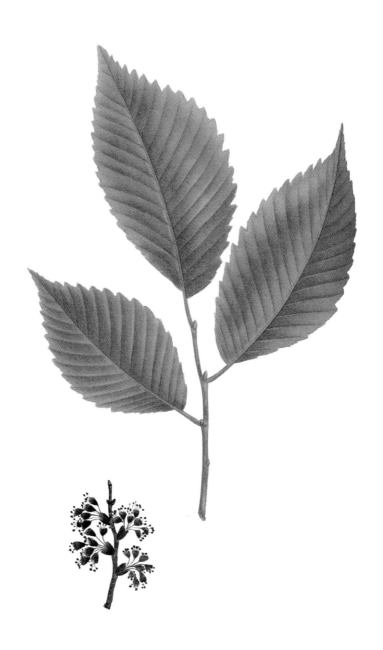

American Elm

The second night I stopped at the sign of the elm-tree. The woods were too wet, and I concluded to make my boat my bed. A superb elm, on a smooth grassy plain a few feet from the water's edge, looked hospitable in the twilight, and I drew my boat up beneath it. I hung my clothes on the jagged edges of its rough bark, and went to bed with the moon, 'in her third quarter', peeping under the branches at me. I had been reading Stevenson's amusing *Travels with a Donkey*, and the lines he pretends to quote from an old play kept running in my head:–

> The bed was made, the room was fit,
> By punctual eve the stars were lit;
> The air was sweet, the water ran;
> > No need was there for maid or man,
> > When we put up, my ass and I,
> > At God's green caravanserai.

But the stately elm played me a trick: it slyly and at long intervals let great drops of water down upon me, now with a sharp smack upon my rubber coat; then with a heavy thud upon the seat in the bow or stern of my boat; then plump into my upturned ear, or upon my uncovered arm, or with a ring into my tin cup, or with a splash into my coffee-pail that stood at my side full of water from a spring I had just passed. After two hours trial I found dropping off to sleep, under such circumstances, was out of the question; so I sprang up, in no very amiable mood toward my host, and drew my boat clean from under the elm. I had refreshing slumber thenceforth, and the birds were astir in the morning long before I was.

John Burroughs, Pepacton *(1881)*

EUCALYPTUS

When I can't sleep, you speak to me of trees.
Of the bald-eyed Eucalyptus
that flared in your back yard
like an astounded relative
pointing to the honey bees in their rickety hives
your brother had abandoned.

Sometimes the tree was avuncular.
Arch with its secrets.
How it boasted, on days
your mother
hung sugarwater,
the delicate surgery of hummingbirds.

Sinéad Morrissey, 'Lullaby',
The State of the Prisons *(2005)*

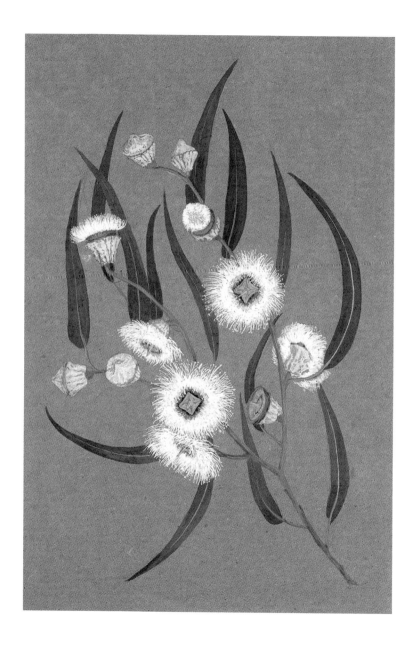

SOUTHERN LIVE OAK

This morning the winds on the great river were high and against me; I was therefore obliged to keep in port a great part of the day, which I employed in little excursions round about my encampment. The Live Oaks are of an astonishing magnitude, and one tree contains a prodigious quantity of timber; yet, comparatively, they are not tall, even in those forests, where growing on strong land, in company with others of great altitude (such as *Fagus sylvatica, Liquidambar, Magnolia grandiflora,* and the high Palm tree) they strive while young to be upon an equality with their neighbours, and to enjoy the influence of the sun-beams, and of the pure animating air. But the others at last prevail, and their proud heads are seen at a great distance, towering far above the rest of the forest. . . . The trunk of the Live Oak is generally from twelve to eighteen feet in girth, and rises ten or twelve feet erect from the earth, some I have seen eighteen or twenty; and then divides itself into three, four, or five great limbs, which continue to grow in a nearly horizontal direction, each limb forming a gentle curve, or arch, from its base to its extremity. I have stepped above fifty paces, on a straight line, from the trunk of one of these trees, to the extremity of the limbs. It is evergreen, and the wood almost incorruptible, even in the open air. It bears a prodigious quantity of fruit; the acorn is small, but sweet and agreeable to the taste when roasted, and is food for almost all animals. The Indians obtain from it a sweet oil, which they use in the cooking of hommony, rice, etc; and they also roast it in hot embers, eating it as we do chestnuts.

William Bartram, Travels *(1791)*

ROWAN

O rowan tree, O rowan tree! thou'lt aye be dear to me!
Intwined thou art wi' mony ties o' hame and infancy.
Thy leaves were aye the first o' spring, thy flowers the simmer's pride;
There wasna sic a bonnie tree in a' the country side.
 O rowan tree!

How fair wert thou in simmer time, wi' a' thy clusters white,
How rich and gay thy autumn dress, wi' berries red and bright!
On thy fair stem were mony names which now nae mair I see,
But they're engraven on my heart – forgot they ne'er can be!
 O rowan tree!

We sat aneath thy spreading shade, the bairnies round thee ran,
They pu'd thy bonnie berries red, and necklaces they strang.
My mother! O I see her still, she smiled our sports to see,
Wi' little Jeanie on her lap, and Jamie at her knee.
 O rowan tree!

O there arose my father's prayer, in holy evening's calm;
How sweet was then my mother's voice in the Martyr's psalm!
Now a' are gane! we meet na mair aneath the rowan tree!
But hallowed thoughts around thee twine o' hame and infancy.
 O rowan tree!

Carolina Oliphant, Lady Nairne, 'The Rowan Tree', Lays from Strathearn (1846)

HAWTHORN

The wintry haw is burning out of season,
crab of the thorn, a small light for small people,
wanting no more from them but that they keep
the wick of self-respect from dying out,
not having to blind them with illumination.
But sometimes when your breath plumes in the frost
it takes the roaming shape of Diogenes
with his lantern, seeking one just man;
so you end up scrutinized from behind the haw
he holds up at eye-level on its twig, and you flinch before
its bonded pith and stone,
its blood-prick that you wish would test and clear you,
its pecked-at ripeness that scans you, then moves on.

Seamus Heaney, 'The Haw Lantern', The Haw Lantern *(1987)*

INDEX OF PLANTS, AUTHORS AND ARTISTS

LIST OF ILLUSTRATIONS

G. S. Boulger (1853-1922), opp. pg.64

p.56–7 Black walnut (*Juglans nigra*), by Ignaz Albrecht, from *Icones plantarum* (1818), by Ferdinand Bernhard Vietz (1772–1815), v.7, pl.589

p.58 European birch (*Betula alba*), by Dorothy Burt Martin (1882–1949)

p.60 Hickory (*Carya glabra*), by Barbara Mary Steyning Everard (1910–90)

p.63 Ginkgo (*Ginkgo biloba*), unsigned plate, from *Flora Japonica* (1870) by Dr. Ph. Fr. De Siebold (1796-1866) & Dr. J. G. Zuccarini, v.2, pl.136

p.64 Swamp cypress (*Taxodium distichum*), by E. S. Weddell, from *Pinetum Woburnense* (1839), by James Forbes (1773–1861), pl. 60

p.66 Palms (*Attalea funifera* (far left and far right), *Cocos coronata* (second to left) *Cocos schizophylla* (second to right) and *Sabal umbraculifera* (centre)), from *Historia Naturalis Palmarum* (1833-1850), by Karl Friedrich Philipp von Martius (1794-1868), v.1, pl. 41

p.69 Horse chestnut (*Aesculus hippocastanum*), by Winifred Baker (*c*.1940)

p.73 White pine (*Pinus strobus*), by Ferdinand Bauer, from *A Description of the Genus Pinus* (1803), by A.B. Lambert (1761-1842), v.1, pl.22

p.74 Field maple (*Acer campestris*), by Ignaz Albrecht, from *Icones plantarum* (1806), by Ferdinand Bernhard Vietz (1772–1815), v.3. pl.225

p.77 Black spruce (*Picea nigra*), by C. Kastner, from *Iconographie des Conifères* (1912-1814) by Leon Gabriel Charles Pardé (1865–1943), v.4, pl.43

p.78 Oak (*Quercus ilex*), by W. H. J. Boot, from *Some Familiar Trees* (1898), by G.S. Boulger (1853-1922), frontispiece

p.83 Cedar of Lebanon (*Cedrus libani*), by Franz Antoine (1815–86) from his *Die Coniferen* (1840), pl. 23

p.84 Ash (*Fraxinus excelsior*), by Ignaz Albrecht, from *Icones plantarum* (1817), by Ferdinand Bernhard Vietz (1772–1815), v.6, pl.519

p.87 Alder (*Alnus cordata*), by Matilda Smith, from *Curtis's Botanical Magazine*, v.142, pl.8658

p.88 Larch, (*Larix decidua*), by Dorothy Burt Martin (1882–1949)

p.91 European beech (*Fagus sylvatica*), by Dorothy Burt Martin (1882–1949)

p.92 Aspen (*Populus tremula*), by Ignaz Albrecht, from *Icones plantarum* (1818), by Ferdinand Bernhard Vietz (1772–1815) v.9, pl.755

p.95 Midland hawthorn (*Crataegus laevigata*), by Dorothy Burt Martin (1882–1949)

p.97 Lombardy poplar (*Populus nigra* var *betulifolia*), from *Curtis's Botanical Magazine* (1910), v.136, pl.8298

p.99 Cabbage tree (*Sabal palmetto*), by C. E. Faxon, from *The Silva of North America* (1896), by Charles Sprague Sargent (1841–1927), v.10, pl.507

p.100 Hazel (*Corylus avellana*), by Dorothy Burt Martin (1882–1949)

p.103 Japanese maple (*Acer (polymorphum) palmatum* var *sanguineum*), by P. Stroobant, from *L'Illustration Horticole* (1867), pl.526

p.105 White oak (*Quercus alba*), by Pierre Joseph Redouté, from Histoire des Chênes de l'Amérique (1801) by André Michaux (1746-1803), pl. 5

ACKNOWLEDGMENTS

The publishers would like to thank Lizzie Fowler (RHS Books) and Charlotte Brooks and Annika Browne (RHS Lindley Library) for their help with this book.

'Stay Again' by Talvikki Ansel reproduced by permission of University of Nebraska Press; 'The Haw Lantern' from *The Haw Lantern* (Faber & Faber, 1987) and 'Planting the Alder' from *District and Circle* (Faber & Faber, 2006) by Seamus Heaney by permission of Faber & Faber Ltd, London, and Farrar Straus and Giroux; 'Where the Beeches' by Judy Gahagan from *Night Calling* (Enitharmon, 2003) by permission of Enitharmon Press; 'The Summit Redwood' by Robinson Jeffers from *The Collected Poetry of Robinson Jeffers*, volume 1, edited by Tim Hunt, copyright © Jeffers Literary Properties by permission of Stanford University Press; extract from *The Flowering of Britain* by Richard Mabey © Richard Mabey (Chatto & Windus 1989) by permission of Sheil Land Associates; 'In the Fall' by Hugh MacDiarmid from *Complete Poems* (Carcanet Press, 1994) by permission of Carcanet Press Ltd; extract from *The Essential Earthman* by Henry Mitchell (Indiana University Press, 1981) by kind permission of Indiana University Press; 'Lullaby' by Sinéad Morrissey from *The State of the Prisons* (Carcanet Press, 2005) by permission of Carcanet Press Ltd; 'Banjo Boomer',edited by Milton J. Bates, and 'Of Mere Being', edited by Milton J. Bates, from *Opus Posthumus*, edited by Milton J. Bates, copyright © 1989 by Holly Stevens. Preface and Selection copyright © 1989 by Alfred A. Knopf, a division of Random House, Inc. Copyright © 1957 by Elsie Stevens and Holly Stevens. Copyright renewed 1985 by Holly Stevens. Used by permission of Vintage Books, a division of Random House, Inc., and Faber & Faber Ltd, London; 'Down by the Salley Gardens' and 'The Song of Wandering Aengus' by William Butler Yeats by permission of A.P. Watt on behalf of Gráinne Yeats, Exectutrix of the Estate of Michael Butler Yeats.

The publishers apologise to any copyright holders that they were unable to trace and would like to hear from them.